unfinished History

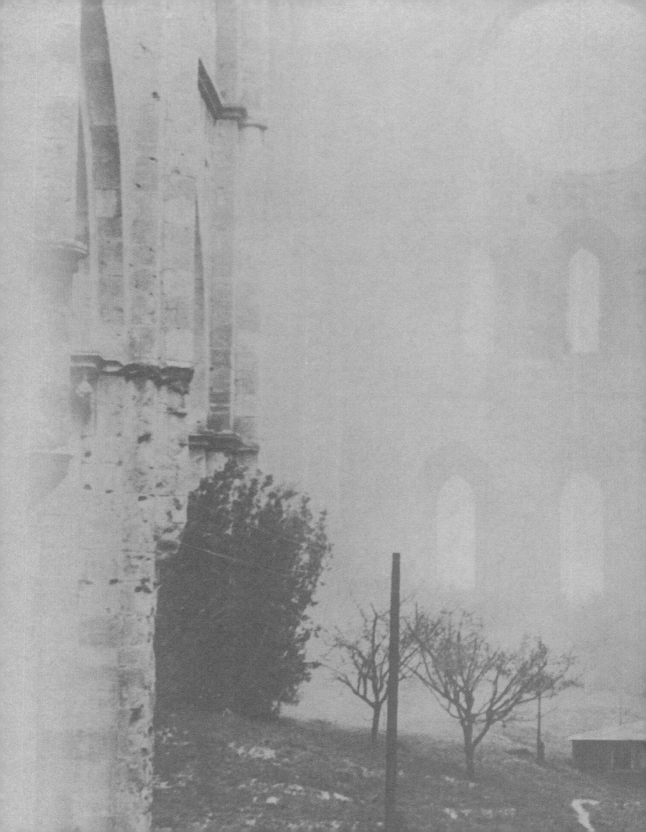

unfinished History

Francesco Bonami

WALKER ART CENTER, MINNEAPOLIS

Published in conjunction with the exhibition *Unfinished History*,
presented at the Walker Art Center October 18, 1998–January 10, 1999.

Guest Curator *Francesco Bonami*
Walker Exhibition Curator *Douglas Fogle*
Curatorial Assistants *Clara Kim, Olukemi Ilesanmi,* and *Anastasia Shartin*
Publication Designers *Andrew Blauvelt* and *Sara Cambridge*
Publications Manager *Michelle Piranio*
Editors *Kathleen McLean* and *Pamela Johnson*

Printed in the United States of America by Print Craft, Minneapolis.

**Available through D.A.P./Distributed Art Publishers, 155 Avenue
of the Americas, 2nd floor, New York, NY 10013.**

Library of Congress Cataloging-in-Publication Data
Unfinished history. -- 1st ed.
p. cm.
Published on the occasion of an exhibition held at the Walker Art Center,
Minneapolis, Minn., Oct. 18, 1998 - Jan. 10, 1999.
ISBN 0-935640-62-2 (pbk. : alk. paper)
1. Art, Modern--2oth century--Exhibitions. I. Walker Art Center.
N6487.M56W358 1998
709'.04'9074776579--dc21 98-41303
 CIP

cover and previous page: Stills from Andrei Tarkovsky's film *Nostalgia*, 1983

contents

6 Foreword
 Kathy Halbreich, Director

8 Acknowledgments

11 A Descent into the Maelstrom
 Douglas Fogle

14 Unfinished History
 Francesco Bonami

33 THOMAS STRUTH
34 MAURIZIO CATTELAN
36 ALEXANDR SOKUROV
38 ALIGHIERO BOETTI
40 BODYS ISEK KINGELEZ
42 GABRIEL OROZCO
46 DOUG AITKEN
50 WILLIAM KENTRIDGE
54 MATS HJELM
58 CADY NOLAND
60 WING YOUNG HUIE
64 S.A.N.A.A. (KAZUYO SEJIMA, RYUE NISHIZAWA & ASSOCIATES)
65 NOX (LARS SPUYBROEK)
66 ANDREA BOWERS
70 PAN SONIC (MIKA VAINIO & ILPO VÄISÄNEN)
71 YUTAKA SONE
72 HUANG YONG PING
76 KOO JEONG-A
78 JAMES ANGUS
80 THOMAS SCHÜTTE
84 SHIRIN NESHAT
86 THOMAS HIRSCHHORN
88 ROMAN SIGNER

89 Artists' Biographies
94 Exhibition Checklist

FOREWORD

KATHY HALBREICH, DIRECTOR

As we approach the end of this century—years in which we have moved from the speed of the loco-motive to that of the Internet—the map of our everyday lives shifts at a startling rate; the boundaries separating and entwining us are seemingly redrawn daily. In the months since we asked Francesco Bonami to create the contours of an international exhibition, the world has undergone a series of unsettling ruptures that have made it difficult to separate the new from the timeworn. India and Pakistan, in testing their own modern nuclear weapons, have escalated a historical war of wills, while North Korea also has compromised its relations with the international community by launching a long-range missile across Japan, its longtime enemy. Iran is conducting military maneuvers on the border of Afghanistan as these two fundamentalist Islamic regimes, divided by their sects, begin a new age of political and military posturing. Civil war has erupted in the Democratic Republic of Congo while bombings at American embassies in Africa suggest an age of international conflict brought about by cultural complaints. The global ripples set in motion by the collapse of the Asian and Russian economic markets reveal the intricate and intimate interdependencies of our global economic system.

As we exit the twentieth century it is clear that, while the rate of change will continue to accel-erate, the historical conflicts underlying such transformations will persist, leaving both the past and future unfinished, open to interpretation. The future is easy to imagine but hard to know; like cave paintings, the signs are both familiar and still unfathomable. In *Unfinished History* Francesco Bonami has brought together twenty-three remarkable contemporary artists from sixteen countries and five continents who, while born in this century, will spend most of their lives in the next. In keeping with both the mission of the Walker and the creative momentum of this moment, this is a multidisciplinary exhibition uniting architects, filmmakers, and performers with visual artists whose contemporary lenses may help us focus our own vision on the still diaphanous scrim we call "the future."

Unfinished History follows in the wake of a number of recent exhibitions at the Walker Art Center devoted to exploring the international intricacies of today's artistic environment. In *Brilliant! New Art from London* (1995) and *no place (like home)* (1997), both organized by Chief Curator Richard Flood, the Walker presented two reflections of the international art world. *Unfinished History* continues the Walker's ongoing commitment to supporting contemporary artists whose visions mirror the pleasures and perils of an interconnected world.

Despite the increasingly international network of artists and curators, exhibitions this ambitious are both more expensive and more difficult to finance. This exhibition would not have been possible without the generous intellectual and financial support of The Rockefeller Foundation, whose com-mitment to the study of international practice across cultures parallels our own efforts. We would also like to extend our thanks to the Elizabeth Firestone Graham Foundation, whose support of emerging artists allowed us to produce a catalogue to accompany this exhibition, and the Andrew W. Mellon Foundation for its ongoing support of Walker publications. Additional support for the participation of

a number of the artists in this exhibition was provided by the Mondriaan Foundation, Amsterdam, the International Artists' Studio Program in Sweden (IASPIS) in Stockholm, and the Finnish Fund for Art Exchange (FRAME) in Helsinki.

Finally, I am also extremely grateful to Assistant Curator Douglas Fogle, who supported guest curator Francesco Bonami at every turn. Douglas and Francesco were unusually cordial and symbiotic partners, e-mailing each other from various points on the globe at all times of the day and freely editing each other's thoughts. Francesco has distinguished himself as being amongst today's most innovative and resourceful independent curators, traveling widely to see artists in their own studios in the places in which they live. His keen, even poignant, awareness of the difficulties of moving with speed across the continents and evaluating work from various cultures serves as the appropriate ballast for all his efforts. The Walker Art Center is proud to provide Francesco with a temporary home in which to realize his vision and to bolster his commitment to new art that challenges what we know as it gives shape to the pleasure of learning.

acknowledgments

Francesco Bonami

I would like to extend my heartfelt thanks to all those who have helped in the conception and realization of this exhibition and publication.

First and foremost, I want to thank the artists whose visions inspired this exhibition: Thomas Struth, Maurizio Cattelan, Alexandr Sokurov, Alighiero Boetti, Bodys Isek Kingelez, Gabriel Orozco, Doug Aitken, William Kentridge, Mats Hjelm, Cady Noland, Wing Young Huie, Kazuyo Sejima and Ryue Nishizawa of S.A.N.A.A., Lars Spuybroek of NOX, Andrea Bowers, Mika Vainio and Ilpo Väisänen of Pan Sonic, Yutaka Sone, Huang Yong Ping, Koo Jeong-a, James Angus, Thomas Schütte, Shirin Neshat, Thomas Hirschhorn, and Roman Signer.

My sincere gratitude also goes out to the lenders who shared important works from their collections, including the Marieluise Hessel Collection at the Center for Curatorial Studies at Bard College, Giordano Boetti, Camille Hoffman, Jean Pigozzi, Rachel and Jean-Pierre Lehmann, and the Castello di Rivoli Museo d'Arte Contemporanea, Rivoli (TO), Italy.

To the galleries and organizations that helped facilitate this exhibition, special thanks go to Mark Fletcher and Anthony D'Offay at Anthony D'Offay Gallery, London, and Thomas Kufus at zero film, Gmbh, Berlin, for their courtesy and organizational contributions to the exhibition. I would also like to thank Caterina Boetti and the Archivio Alighiero Boetti, Rome; Gavin Brown and Kirsty Bell at Gavin Brown's enterprise, New York; Marcia Acita at Bard College, Annandale-on-Hudson, New York; Lisa Spellman at 303 Gallery, New York; Barbara Gladstone at Barbara Gladstone Gallery, New York; Niklas Svennung at Niklas Svennung Gallery, New York; Jack Tilton and Susan Maruska at Jack Tilton Gallery, New York; Andrew Richards and Marian Goodman at Marian Goodman Gallery, New York; Barbara Weiss at Galerie Barbara Weiss, Berlin; Jin Hosoya at S.A.N.A.A., Tokyo; Angela Choon, Hannah Schouwink, and David Zwirner at David Zwirner Gallery, New York; Linda Givon at the Goodman Gallery, Johannesburg; Massimo De Carlo at Massimo De Carlo Gallery, Milan; Gilda Williams at Phaidon Press, London; André Magnin; Renata Kness; Hans Ulrich Obrist; Okwui Enwezor; Octavio Zaya; Hou Hanru; and Lina Bertucci.

At the Walker Art Center I would like to thank Director Kathy Halbreich for the challenging freedom she granted me in conceiving and developing this exhibition; Chief Curator Richard Flood, whose ideas and profound reflections have been pivotal to the final shape of the exhibition; and Assistant Curator Douglas Fogle, with whom I shared more than just a collaboration but a series of enlightening exchanges of ideas that have been an essential contribution in defining the exhibition.

In the Visual Arts Department, Lila Wallace Curatorial Intern Clara Kim and Curatorial/Education Intern Jenelle Porter made valuable contributions to the catalogue, while their successor, Lila Wallace Curatorial Intern Olukemi Ilesanmi, contributed her energy to the installation and Visual Arts Assistant Henrietta Dwyer calmly oversaw many of the myriad administrative details of the exhibition. In the Registration Department, special thanks go to Assistant Registrar Elizabeth Peck, who heroically

organized an extremely complicated shipping schedule, and to Associate Registrar Liz Glawe, who ably oversaw the care and handling of the artwork.

For creating a wonderful installation in the galleries, I am indebted to Cameron Zebron and his staff in Program Services, especially Kirsten Hanson and Peter Murphy. Their dedication makes this institution a truly special place for artists (and guest curators) to work.

For their timely advice and counsel on particular aspects of this exhibition, I would also like to thank Performing Arts Curator Philip Bither and Film/Video Curator Bruce Jenkins.

In the Development Department I would like to thank Director Katharine DeShaw and her colleagues Kathryn Ross and Aaron Mack for their unflagging efforts in making this exhibition financially possible. Thanks go as well to the exhibition's fiscal caretakers, Administrative Director David Galligan and Finance Director Mary Polta.

Thanks go also to Director of Education and Community Programs Karen Moss and her talented staff, including Associate Director Sarah Schultz and Curatorial Assistant Anastasia Shartin, who organized the exhibition-related educational programs and made sensitive contributions to the interpretative materials for this exhibition.

I am also extremely indebted to the Walker Art Center Design Department staff for their work on this publication and the installation graphics. I would especially like to thank Design Director Andrew Blauvelt and Graphic Designer Sara Cambridge, who are responsible for the design of this catalogue. Publications Manager Michelle Piranio magically made this book float comfortably within a sea of other publications, while Editor Kathleen McLean and Assistant Editor Pamela Johnson carefully oversaw its words. Additional help on this publication was provided by Photographer Dan Dennehy, who spent tireless hours engineering the photography for the catalogue, while Librarian Rosemary Furtak helped track down many elusive facts.

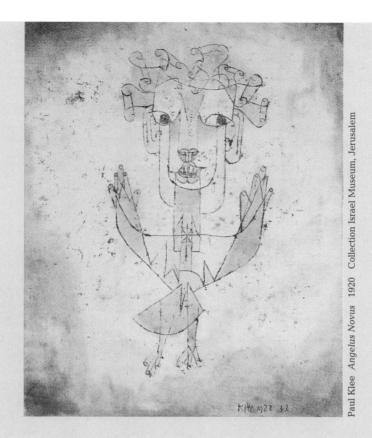

Paul Klee *Angelus Novus* 1920 Collection Israel Museum, Jerusalem

a Descent into the Maelstrom

Douglas Fogle

"A Klee painting named *Angelus Novus* shows an angel looking as though he is about to move away from something he is fixedly contemplating. His eyes are staring, his mouth is open, his wings are spread. This is how one pictures the angel of history. His face is turned toward the past. Where we perceive a chain of events, he sees one single catastrophe which keeps piling wreckage upon wreckage and hurls it in front of his feet. The angel would like to stay, awaken the dead, and make whole what has been smashed. But a storm is blowing from Paradise; it has got caught in his wings with such violence that the angel can no longer close them. This storm irresistibly propels him into the future to which his back is turned, while the pile of debris before him grows skyward. This storm is what we call progress."

—Walter Benjamin, "Theses on the Philosophy of History"[1]

In the fall of 1940, a few months after he drafted his "Theses on the Philosophy of History," literary critic-philosopher Walter Benjamin was directly confronted by History as he attempted to flee Nazi-occupied France by crossing the border into Spain. As a German Jew whose intellectual inclinations led him to identify with Marxism, Benjamin was highly motivated to take his leave of France, but as his party of refugees arrived at Port Bou in the French Pyrenees, the Spanish authorities closed the border. Devastated by this development and by the prospect of capture by the Gestapo, Benjamin took his own life by ingesting an overdose of morphine. Ironically, the Spanish authorities were so shaken by his suicide that the rest of Benjamin's party was allowed to cross the border and proceed into Spain the very next day.

Some fifty years later, Russian filmmaker Alexandr Sokurov would take his video camera to another border, this one dividing the newly independent Tadzhikistan Republic from Afghanistan, the site of the Soviet Union's own Vietnam in the 1980s. In his five-and-one-half-hour film *Spiritual Voices* (1995), Sokurov would document the lives of a group of young soldiers conscripted into the Russian military to guard this newly activated border. As much a meditation on loneliness and sorrow in the modern world as it is about the geopolitical realities of an empire in collapse, Sokurov's film alludes to the entanglement of personal history with the unfinished history of the new world order, while Benjamin's personal tragedy evokes the crucible in which this world was initially forged.

Benjamin's predicament in 1940 and that of Sokurov's Russian soldiers in 1995 are familiar ones today, standing in as metaphors for the individual spirit confronted by a world fragmented by the vagaries of international politics or the emergence of a seemingly all-pervasive global communications network. Like Vladimir and Estragon in Samuel Beckett's play *Waiting for Godot*, this century has been one in which we have all been sitting on a border waiting for our very own Godots. But perhaps what we were really waiting for was Benjamin's angel of history to come down from above and "make whole what has been smashed." For some, the wait seemed to have ended in 1989, and the pile of debris accumulating at the angel's feet turned out to be the rubble of the Berlin Wall. With the destruction of this barrier came an end to the belligerent detente of the Cold War. Victory was proclaimed for the West, a New World Order was declared, and a golden age of global liberal democracy was announced. As international relations analyst Francis Fukuyama suggested in his controversial 1989 article "The End of History?," "what we may be witnessing is not just an end of the Cold War, or the passing of a particular period of postwar history, but the end of history as such; that is, the end point of mankind's ideological evolution and the universalization of Western liberal democracy as the final form of human government." [2]

But, of course, things didn't really work out that way. The genocidal convulsions of Bosnia and Rwanda alone were enough to provide a wake-up call and a tragic antidote to the euphoria surrounding the end of the Cold War, signaling a terrible and menacing return of historical ethnic antagonisms that are still manifesting their effects in 1998. History stutters. The exhibition *Unfinished History* is an attempt to listen to this stutter and the resultant complexities of a contemporary world in which the sober certainties of the Cold War have given way to the resuscitated rivalries and hysterical stigmata of long-repressed histories.

In *Unfinished History*, guest curator Francesco Bonami has brought together twenty-three artists from across the globe, connected not by their biographies or their specific national identities but rather by their status as members of the last generation of the twentieth century. Like Benjamin's angel of history, which looks backwards as the winds of history sweep it forward, these artists are

caught within the gravitational pull of the century they are leaving while being inexorably thrust forward toward its conclusion. Unable to imagine the future, they bear witness to the contradictions and transformations within the present as they are informed by the past.

Working in a wide range of media, including installation, film, video, photography, sound, architecture, and sculpture, the artists in this exhibition reflect the multiplicity of individual artistic approaches to the problems we all confront in a world of increasingly fluid borders where past, present, and future collapse into a set of contradictory positions and at times unsolvable issues.

But this exhibition is neither a broad survey of international artists nor an attempt to didactically map the political symptoms of the post-Cold War global situation. It is rather a meditation on the conditions of producing art within the boundaries of the paradoxically homogeneous and fragmented world that appeared after 1989. As Francesco Bonami suggests in his essay for this catalogue, the exhibition *Unfinished History* is a work of translation that constructs a narrative in which artworks become the visual subtext of larger cultural transformations, offering tentative solutions to the conundrums and cul-de-sacs posed by the convulsions of History. But these artworks also speak to the creative relationships between artists and the world they inhabit, suggesting that art itself might be seen as the spiritual voice of History, a vocal witness to the unconscious passage of History's events.

The world that we inhabit today might be seen through the lens of a tale by Edgar Allan Poe entitled "A Descent into the Maelström." In this story, a Norwegian mariner recounts his escape from a vortex in the sea. Studying the flotsam and jetsam surrounding his ship as it was being pulled to the bottom, Poe's sailor determined that the only way to save himself from certain destruction was to throw himself off his vessel into the heart of the whirlpool. Throughout his career, educator-communications theorist Marshall McLuhan often spoke of the action of Poe's mariner as offering a possible strategem for negotiating the contemporary predicament of a global culture that has lost its own moorings and has been set adrift in a sea littered with the wreckage of History.

This is the strategy followed by the artists in *Unfinished History*, which is embodied in the image that opens this exhibition and also adorns the cover of this catalogue. The Russian dacha situated within the ruins of the Italian cathedral in Andrei Tarkovsky's film *Nostalgia* is the exhibition's own raft, swirling around the vortex in which personal memories float amongst the debris of History. It is by embracing and negotiating the centrifugal force of the maelstrom of History that the artists in this exhibition have emerged from the other side relatively unscathed, ready to bear witness, like Poe's mariner, to the movements of the vortex: "I no longer hesitated what to do. I resolved to lash myself securely to the water cask upon which I now held, to cut it loose from the counter, and to throw myself with it into the water."[3]

1. Walter Benjamin, "Theses on the Philosophy of History" (1940) in *Illuminations*, Hannah Arendt, ed. (New York: Schocken, 1969), pp. 257–258.
2. Francis Fukuyama, "The End of History?," *National Interest*, no. 16 (Summer 1989), p. 4.
3. Edgar Allan Poe, "A Descent into the Maelström" (1841) in *The Fall of the House of Usher and Other Writings* (London: Penguin Books, 1987), p. 240.

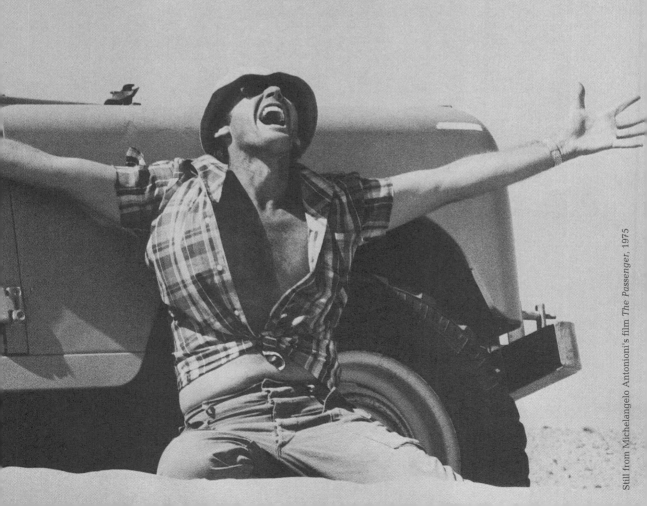

Still from Michelangelo Antonioni's film *The Passenger*, 1975

unFinisHed History

FRancesco Bonami

Millennium Celebrations: Go to Florence where the bells at Bargello are due to ring, as usual, every 100 years. Enter a marathon in New Zealand. Begin a round-the-world bike trip to benefit humanitarian causes. Stay at home and fix your computer's dates; it can't handle three zeros. A trip to Greece? Wait until the year 2001, following the decimal system. Go trekking in the Himalayas with five American women, ten English men, and an Australian couple.

I listened carefully to the radio program broadcasting these unappetizing millennial menus, and came to the conclusion that this year, 1998, has been a very long one. A year ago, before *Unfinished History* was even a concept, I was in South Africa for the *2nd Johannesburg Biennale 1997*. Each day, buses left for field trips to different townships—Soweto, Elizabeth, Alexandra. I witnessed a tourism of anguish, scavengers on multicultural safaris. Tourism = Home Plus. Home plus residual apartheid, plus truth, plus guilt, plus peripheral art, plus exotic strategies. In December I was in Delhi—home plus bottled water, plus spiritual negotiations, plus cheap taxis and endless bargaining. I graze the surface of the future. Today, India has the atomic bomb and we say, "No you can't!" "Why?" "Because you are too many and we really don't trust your religious attitudes or your quixotic politics." "But *you* have it." "Yes, but we don't get excited about it and we know how to use it." History is not working any longer. I often use the word "we," but I don't know who I'm speaking for.

I started to think about *Unfinished History* as an exhibition made of great differences, in which no individual artist could be subsumed into the group. An exhibition based on primary relationships, on communication flowing in both directions, in any direction—from the artists outward to the public or from the public inward to the exhibition's center, or around the margins of it all. To do so, I would need to address my role as a curator—was I a cultural hero, a foreign correspondent, a tourist, or an entrepreneur? I found myself caught in an intricate system of mirrors, where the present and past were confused and the future was just a glimmer. I found no intersecting roads, only a system of woven visions, liquid circumstances. Our century has been lifted up like the horse in maurizio cattelan's sculpture *Novecento (Twentieth Century)* **(1997)**, but the weight of its issues pulls it back to the ground. I, too, find myself pulled to the ground where issues in contemporary art must be solved, if not addressed anew yet again.

There is a History within the exhibition that leads toward many different Histories, different paths to simulate an international atmosphere that has been lost in the age of ethnic and nationalist revaluation. Before the international community there was the one-way mirror of a Western community: now that the compass has become a funnel, we are all falling into an international abyss, a global chaos in which—paraphrasing Chairman Mao's assumption that chaos is the perfect condition for a society in transformation—the situation might be truly "excellent." I am scared, because without a center the margins might vanish, yet this possibility is more fascinating than watching the center become a fossil —a fossil held together by pride.

Unfinished History started as a slow journey back home to Europe, which might be the continent that has been most transformed by History and the one that keeps sliding back into it most aggressively, receding into a past that is becoming its own filmic remake over and over again. Three decades are paving the road back to the future of my memories: the early 1960s, the 1970s, and the early 1980s. Years as milestones along the narrative path of the exhibition. The 1960s and 1970s were a time when people thought that things really could change. In the 1980s, we thought that everything had changed forever—bravo! In the 1990s, we are now accepting the fact that things will not change all that much, all that fast, or all that soon, and when they do it won't only be for the better.

What is confusing today is that there are no differences (the global dream)—yet everything is different (the fragmented world). A decade ago we could have said to others, "We are better," and they would have believed us. Now, while we are still completely different, we don't know who is better—maybe they think they are better, but maybe we are just the same. Eventually we understand that similarities make people fight, and maybe that's why the Western contemporary art world has been unable to produce a single new movement in more than a decade, but only a lot of similar individuals. It's the unconscious realization that, as Freud claimed, the narcissism of minor differences can generate only hostility, and it's in this light that curatorial practices have recently undergone a major transformation.

Similarities make people fight. Joseph Kosuth fought with Lawrence Wiener about who created the first conceptual work, but History forgets more than we do. And nothing really matters when Leningrad changes its name, erasing the mesmerizing power of an entire revolution, or when teenagers have no clue as to how Pol Pot changed the world. History washes away hubris and pain, sorrow and power. Conceptualism could then be just a pinprick in the map of Art History. Yet, the maps of alighiero boetti carry with them the memories of the hands of the Afghani women who wove the colors of nations and oceans into these tapestries. Today these women are dying under an ancient law that forbids them to work, to enter a hospital, to bring food home when their husbands cannot

come home any longer, killed in a civil war of minor differences. Local justice and global injustice. It's the future, then, that casts its shadow over the present, into the past, where ideals become confused with ideologies, dragging some fundamental hope into a deeper fundamentalist despair. We stare, we acquiesce.

We look for the unknown, yet we beg to be known on some level, seeking a point of aesthetic reference, a conceptual adapter into which we can insert our intellectual plug. At the end of the 1960s the Tropicália movement in Brazil used "anthropophagy," cultural cannibalism, to create an independent language. They sampled the smorgasbord of cultures in Europe and Africa and chewed them into a kind of liquid, musical freedom. Today we are floating over an ocean of cultural differences, the debris of past diversities, and to survive the upcoming millennium, we all nibble on one another like a downed soccer team "alive" in the Andes.

Marx worried about the French having too many memories of the past. The drama today is that we live with too many memories of the future, and still we have cultural Alzheimer's. Do we remember how bad the hole in the ozone layer will be when everyone in China has cars and refrigerators? Or what will happen to Venice when millions of Asians become middle-class tourists and land in Piazza San Marco, even just for a day trip? No, we don't remember.

maurizio cattelan was invited to exhibit in the *IX India Triennial* and submitted a stuffed cow with scooter handles in place of its horns. At the time I thought it was a bad prank, but after visiting India I understood the complexity of the reality surrounding me, where religious habits mingle with an autarchic industry, creating a mixture of secular, condescending, and day-to-day spiritual attitudes. His piece was rejected.

The title of foreign correspondent Edward Behr's autobiography was *Anyone here been raped & speaks English?*[1] A real experience told with our voice, our language. Traveling around the margins of the contemporary art world, I have a similar question during every research trip: "Anyone here been raped and know anything about Minimalism?" It seems that we, as curators, are seeking an original voice only if it is expressed through our system of signs, for our theoretical comfort — the mud hut with air conditioning, the computer-generated wooden spoon, the sled with bionic dogs. Yes, the "other," but the one who learns how to be "otherized" through a basic bibliographic dominion.

The viewers at the Louvre are staring at Géricault's *The Raft of the Medusa* (1818–1819) in thomas struth's photograph *Musée du Louvre 4, Paris* (1989), just as we stare at them, just as others are staring at us in an endless chain of gazes, all of us sinking on our own raft into an ocean of unfinished History. Global rafts, cosmopolitan rafts. Are the Italian travelers who smuggle chunks of parmesan into the unknown world, the Nigerian travelers who smuggle dry fish into Heathrow Airport, or the American tourists looking for a McDonald's in Teheran cosmopolitan individuals, aware of the diversity in this world? No, they are not, because they don't accept the fact that geographical realities cannot be exported and that transformation happens only when we are ready to accept new information, to receive it with no compromises.

We must leave — even momentarily — our identities behind, in order to move ahead into a world made of real differences, into a dialogue where English is nothing but a useful tool, a medium of exchange, and not a language related to a people, a country, a History. The art world is looking for smugglers of ethnic and political memories: Miroslaw Balka, Ilya Kabakov, Anish Kapoor, Kcho, william kentridge, Jannis Kounellis, Tracey Moffatt, shirin neshat, gabriel orozco, huang yong ping, or even Anselm Kiefer and Gerhard Richter, who have hidden in their luggage the forbidden longings for a

past that cannot be transferred to the future. We look for these artists in the same way we search for illegal immigrants: We want them because we need them; it is through them that our History is proved, and through them that our historical influence is affirmed and confirmed. Anguish is hiding in the past or rushing into the future, avoiding the present where intolerance abides. But intolerance is a willful refusal to focus on individual differences, though we perversely insist that individual identity has to be subsumed into the group identity. That's why today most wars are civil wars.

According to Bertolt Brecht, you should never start something with the good old things but rather with the bad new things, but I did anyway. As cornerstones in this exhibition's concept and structure, I used those images from our collective cinematographic memory of a time when the world appeared deaf and marvelous, monstrous in its dispersion of intellectual energy. Movies stand in as mnemonic clips, bookmarks for a checklist. After all, it is not the Internet that brought us all together, but movies—this communal language where storytelling, politics, social pleasures, and entertainment met on a plateau where, lights off, the world could be amazed and persuaded, moved and indoctrinated at the same time.

In the dark theater, interaction was real, made active and neutralized by each of us. The audience was enlightened and numbed by its reflection on the giant screen. Then, the world was strangely out of scale, palpably real but ungraspable—a dream that from the 1960s to the end of the 1970s was also a utopia, an ideal, an ideology, a foreshadowing. It was around movies that a generation shared its frustration, rage, and dysfunction. Film was a "piazza," an arena where the individual agenda melted into the group. We felt then that through the screen we could finally judge and carry out the sentence on a world that was then a melting pot of injustice. Smoke clouded each theater in the Western world; it was the fog of a revolution that, once dissolved, left the aisles littered with the butts of too many unanswered questions.

The century was—maybe—just really beginning. We believed we opened it, and yet we just went tumbling down a rabbit hole. The theaters functioned as places of egalitarian cultural propaganda, but it was the artistry of its projected visions that sustained the vices of unrepentant ideology, not the other way around. Europe then was that *socle du monde* turned upside down, not by Italian artist Piero Manzoni, but by a generation that followed his iconoclasm, tilting society and using the movie screen as the temporary sky of a very temporary utopian landscape. Some movies were symbolic *dazibaos*[2] of moving perspectives in a society that slid abruptly away from its conscience.

Today, few of those movies carry the traumatic sting they inflicted on my generation, yet those that still do function as the subliminal hinges of this exhibition. They can inform each work in the draft of their movement, like the swinging doors in GABRIEL OROZCO's installation *Kitchen Door Maze* (1997), which, within the space, both block and invite the viewer—a passenger on the unstable vessel that this exhibition represents.

Andrei Tarkovsky, *Andrei Rublev* (U.S.S.R., 1966): The huge bell cast under the direction of the young Boriska is hung in the scaffolding; if it does not ring, the Russian prince will kill Boriska. But the bell sounds for miles and miles around. Boriska weeps—he'd bluffed. He'd never learned his dead father's secret, how to cast a bell. He invented his expertise and reversed his own destiny. There is a moment of excruciating silence when the clapper inside the bell is swinging but not yet touching the bronze, that infinite instant in which every artist's ideas are waiting to be judged, every individual effort is suspended in the void of looming failure. Maybe our century is in that very instant now, still swinging inside the belly of that immense bell called History.

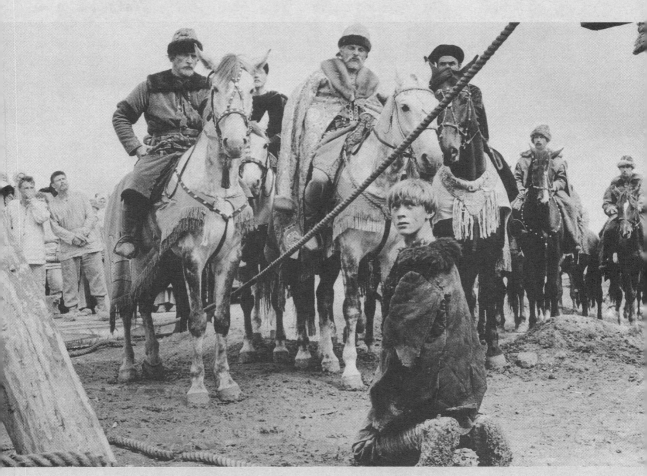

Still from Andrei Tarkovsky's film *Andrei Rublev,* 1966

Luchino Visconti, *The Leopard* (Italy, 1963): Prince Salina (Burt Lancaster), after an endless ceremonial ball, walks alone at night along the road in his small Sicilian village. Italy will soon be unified (1870) and his domain will end; yesterday will begin tomorrow. A cowboy—as Visconti called Lancaster—was able to embody the ancient, the transformation of a past into a future, assuming the symbolic role of a destiny that agrees to disappear in order to transform the future. Like the young Boriska, Prince Salina is listening for that sound he imagined for so long in his mind—the sound of the past that expands into the present toward the future. We all imagine that sound, we all bluff, because nobody knows the secret of how to create that perfect sound we once called civilization. It is, in fact, through a series of barbaric experiences that civilization vibrates in our ears.

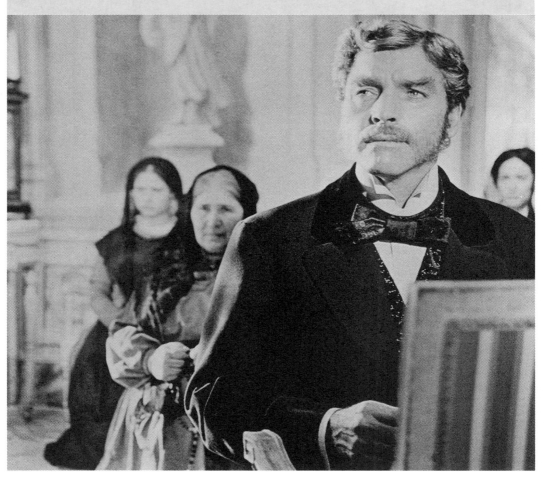

Still from Luchino Visconti's film *The Leopard*, 1963

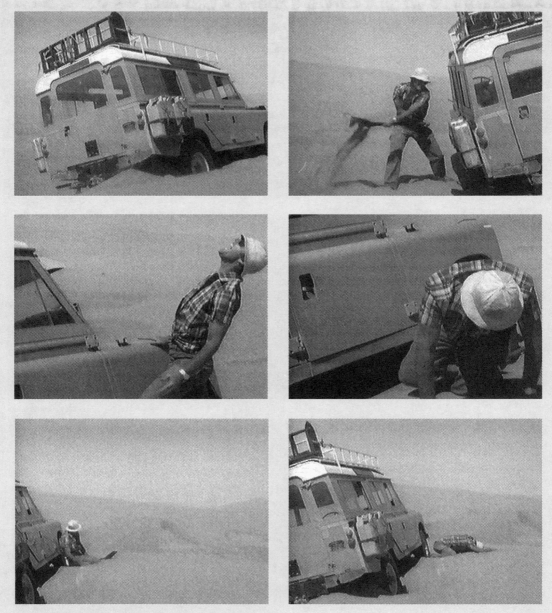

Stills from Michelangelo Antonioni's film *The Passenger,* 1975

Michelangelo Antonioni, *The Passenger* (Italy/U.S., 1975): Jack Nicholson's jeep is stuck in the desert sands—an image close to our contemporary culture, stuck in the future's sands with the future's best tool—an intellectual jeep that can lead us nowhere. Maybe it is History that is becoming sand, a desert surrounding what we call art and culture. Art has been a vehicle that moves across the centuries, along the border of what we call progress. But art never really traveled in a linear way; it moved along the desert trail, oblivious to the danger of getting lost or stuck, while the rest of society chose the incomplete, bumpy, but safe trail of progress.

Gillo Pontecorvo, *The Battle of Algiers* (Italy/France, 1966): Some Algerian women transform themselves, cutting their hair, becoming "French" in order to cross the army blockades in Algiers and plant the bombs that will trigger the revolution against the colonizing power—changing identities to regain the identity of a country, of a people. Today the same women are slaughtered because their country's identity has been disrupted, their existence negated, the freedom they once fought for canceled by the tangle of History and Religion gone mad. Could any of the most brutal performances that paved the progress of contemporary art even come close to the gush of innocent blood the world is witnessing today with the same indifference as those conservative viewers who dismissed the creative feats of people such as Rudolf Schwarzkogler, Hermann Nitsch, or Chris Burden? The answer is perhaps irrelevant, but we can no longer dismiss the pathetic performance of a society that turns a blind eye both to partisan atrocities and the creative attempt of art to treat, at least momentarily, some of the putrid wounds of our time.

Werner Herzog, *Stroszek* (Germany, 1978): Bruno, the main character, activates the "evil" sideshow display at an amusement park before committing suicide. The display is comprised of coin-operated window boxes in which pets obey mechanical impulses to perform anthropomorphic actions — a rabbit "fireman" runs to turn on an alarm, a hen "dances," another plays the piano with its beak. To survive in a dehumanized society, we all perform a social role to avoid turning into violent animals. Yet Bruno is perhaps the best icon to represent the tragic moment of dislocated identities. Communities are moved from their countries in order to be saved from extermination or famine, but by moving the group, we end up with a multilayered individual with all the dysfunctions of a nation as well as all the paranoias of the single person. With this frame of mind, we might start to perceive most of the artists in this exhibition as icons of a dislocated people and of a wandering individual, removed from their geographical legacy and social context, yet projected into another possible world—one containing their art and its viewers.

Stills from Werner Herzog's film *Stroszek*, 1978

22

Stills from Gillo Pontecorvo's film *The Battle of Algiers*, 1966

Andrei TarMovsMy, *Nostalgia* (Italy/U.S.S.R., 1983): The last image of the film shows places where GorcaMov, a Russian poet and the film's protagonist, used to return to in his mind – the country house in Russia with its slope toward the river. Here the writer sits with his dog while the camera recedes, framing the roofless cathedral of San Galgano in Tuscany, where it is lightly snowing. Private recollections place the individual in a historical context, giving History the sense of scale that its overwhelming events neglect. It is our sense of proportion that gives History a sense of reality, our personal times that compose it over the course of a century. We divide monolithic chunks of time into simple fragments of insignificant existence that are more immortal than the lives of kings, queens, and dictators. It is this system of Russian dolls where private images, both public and historical, are contained inside each other. We open the doll because we want to know how small the last will be. It is the smallest that gives meaning to our search. We look at the millennium and we end up with a fraction of time, that fraction when the bell will finally ring or will stay silent.

My father's cursing the fates broMe the silence of History for me and was the bell that installed memory in my generation, transforming John F. Kennedy's death in Dallas into a personal tragedy that I still remember vividly. It was a splinter in the History of the world, but the first landmark of my generation to define our idea of America. It was perhaps the first televised event that involved History and Reality at the same time. Television was still a novelty in Italy then—not yet an appliance but a device that defined some kind of class structure, erasing forever the equalizing power of World War II. Kennedy's funeral was almost a static event to me. I remember watching the procession moving in slow motion behind the coffin, but the speed of the economic boom propelling Europe contradicted those fuzzy black-and-white images. The TV set is newer but still sitting in the same place, while my memory and collective dreams have turned almost 360 degrees around.

Michelangelo Antonioni, *The Passenger* (again): In the final sequence, the camera enters the hotel room where JacM Nicholson lies dead on his bed. Slowly the camera pans the room and then the square of a Spanish village—360 degrees—the end of a life while life keeps on going outside. For this exhibition, it may serve as a reflection of a History at 360 degrees, inside-out: a room with a world inside and another all around. The exhibition as one small room where many different events are happening, insignificant for some, lethal for others, powerful, hopefully, for many.

TarMovsMy, Pontecorvo, Visconti, Antonioni, and Herzog anticipated the trouble that would haunt the end of this century. Through their films each of them, in one way or another, understood that our History was going to be compressed into a much smaller file so it could be loaded more easily into the system folder of the next millennium. They tried to expand the concept of time in their films and the existential frame that contains each individual time. So many questions were going to be lost in this passage, and these directors felt it as a threat. Their movies reflect both the desire to understand our century and the fear of forgetting to answer some of the most important questions. I feel that the artists in *Unfinished History* share the same frame of mind as those directors, living in a very different time but on the same wavelength. Their work dredges up desire and fear, perhaps the most basic ingredients needed to survive intellectually amidst the cultural fireworks of a shifting society.

As the Swiss artist THOMAS HIRSCHHORN would say, "I'm trying to connect things that I don't understand." As a curator my approach is similar: trying to connect things that I don't understand inside with artistic events outside that I also can't understand. This series of connections creates the exhibition's narrative, where the viewer will play the role of reader, following some of the exhibition's logic and creating his or her own on top of it. Getting lost, as I did in the making of this exhibition, and then

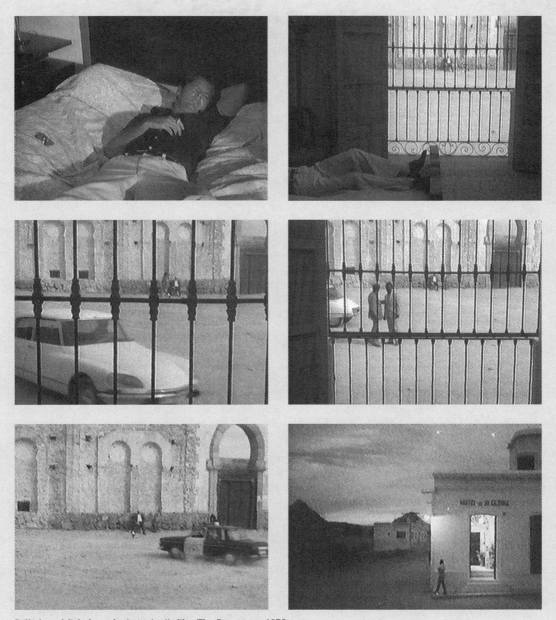

Stills from Michelangelo Antonioni's film *The Passenger*, 1975

finding the way again—maybe from a completely different direction, maybe from a space inside the mind we weren't supposed to find.

A horse is hanging from the ceiling, its legs elongated as gravity pulls it back down into the world. maurizio cattelan's *Novecento (Twentieth Century)* (1997) is a convex vision of Italian history, a synopsis of the conflicting changes of our century. Agriculture sucked into an industrializing stampede only to end in a society weighed down by media consumption. A blueprint for the world and a reflection on the unlikely marriage of ideology and religion, enacted by the biggest Communist Party of the Western world (PCI) and the Catholic masses represented by the Pope in Vatican City. While the Communist Party succeeded in a strategic metamorphosis after the fall of the Berlin Wall, Pope John Paul II escaped both local and Western decline, becoming the messenger of a global spirituality—enacting the last crusade against capitalism and injustice. Nevertheless, this ecumenical or global Church also embodies the last colonizing power of this century, conquering souls while imposing the obsolete moral rules that are eroding the body of the contemporary individual forced to choose between the Christian faith and the unsustainable weight of overpopulation or the brutal spread of the AIDS virus that feeds the anguish of the African continent. Hope without reality or reality without any hope?

The horse then appears as a fallen icon of a noble heritage, denying metamorphosis or possible escape. Like Prince Salina in Visconti's *The Leopard*, it feels at once the lightness of extinction and the heavy decrepitude of a powerless reaction. The horse is this century lifted up by another century, but its historical gravity pulls its legs down to the ground. Eventually a century pulls on the legs of an entire millennium. So do the soldiers of alexandr sokurov's film *Spiritual Voices* (1995)—but they are insignificant pawns in a game that's forgotten most of its rules. Abandoned at the border of some lost province of the Soviet empire, they wait for the enemy. Nothing happens; people age and die, waiting for a moment when life takes on some kind of meaning. These soldiers reflect the state of our culture, always on the border of a future that is so fast that it never arrives. We wait for the millennium because we have nothing else to wait for.

Meanwhile, surrounded by borders they would never see, a number of Afghani women were weaving alighiero boetti's map of a changed world, *Mappa* (1992–1993). It is not a map of the "Other World" but the map of "Another World," an embroidered vision of reality suddenly changed in all its colors. The red of the Soviet Union and China used to be a large, expanding stain over the earth, but in this map, a blue horizon now divides chaos from order, freedom from future, danger from fear. The artist grasped in this *Mappa*, two years before his death, a world destined to see the hues of its colors changing like leaves, an endless autumn of a political and social free fall. He used to say, "Next to myself is me." Today, next to the world is the world—a mirrored state of differences and similarities: the "M" of McDonald's that rises in front of the lush vegetation of Indonesia, or in front of the ghost palace of Ceaucescu in Bucharest. Or in Kinshasa—the real Kinshasa—the capital of Congo, formerly Zaire, formerly Congo. bodys isek kingelez's *Ville Fantôme* (1996) is not a postmodern dream but an unjaded, quasi-architectural approach to a place (Kinshasa) before despair became an architectonic style. A fantasy before reality checked in. A city as a maze of deluded illusions. Language as a maze where meanings are mere traces.

Inside gabriel orozco's *Kitchen Door Maze* (1997) we are adrift among the remains of lost directions, names on a map that have been eroded. We can't follow the colors because the colors are following us. We are lost until the swinging doors express the space's logic. We are displaced beings in a realm

of possibilities and directions. The doors of the world used to swing in only two directions—west/east or south/north. Now they move so fast that they appear permanently open, but they are not.

The nomads of the earth are an endless ring around the globe. Still, the deserts exist. While lands are jammed and overpopulated, other spaces stay intact, preserved from the pollution of individual presences, protected as nature reserves, like the Namibia Desert where DOUG AITKEN shot his projection *Diamond Sea* (1997). A land full of diamonds, lost in the realm of profit, secluded from reality, the provider of dreams. Eventually it will empty out and be left to those who will exploit its beauty and transform it from a black spot on the map into a crowded resort of frustration. The artist shows us a place devoid of human presence, a utopia or a nightmare, depending on which side of History we decide to look at it from.

WILLIAM KENTRIDGE's animated drawings are meditations on a luminous site, not far from the gray shades of contemporary South Africa, where the land does not hide the glitter of diamonds but dark memories of a violence that went beyond revenge, approaching truth from the opposite direction. His work evokes the memory of that landscape, a mute reality that never reveals the guilt of its visitors. An interpretation of horror rather than an eyewitness account from a victim that remains distant to us as long as we don't become victims ourselves.

Johannesburg is a city scarred by historical neglect, where memories have different colors and some are transparent. Detroit was scarred by a saturation of injustice, an unbalanced demography. MATS HJELM traces the stitches suturing these wounds by blending his father's film footage of the 1967 Detroit riots with his own more recent trip to that city to interview some of the aging figures of the Black Power Movement. *White Flight* (1997) is an inquiry into the witness' eye, a person's capacity to truly remember why all of this happened. People run away without ever looking back. The artist tries to look back for them, in order to know if it is possible to look forward today through the shadow of injustice, beyond the bumps that these scars left in the political and social body of a democratic society. This is a society that an antihero, Lee Harvey Oswald, snapped in half one day in November 1963.

History defined by a moment can become an obsession, and CADY NOLAND cuts these obsessions into metal, in order to transform History into its own pathetic advertisement. In *Oozewald* (1989), Oswald is choked by a flag to avoid the noise of his scream, the noise of a time that looked too good to be true. The American Dream ended before we ever woke up. It later turned into a nightmare when Patricia Hearst became "Tania," a guerrilla fighter in the Symbionese Liberation Army (SLA), a hero for a generation raised in the school of resentment. While leaning out of the window of time, watching the enemy on the sidewalk, America failed to watch as its children were inside burning down the house. Yesterday the SLA, today the Oklahoma City bombing. There is always the chance that our world will implode under the weight of too many dreams.

Whose dreams will we follow along Lake Street in Minneapolis, where communities of Hmong, Cambodian, Laotian, Somali, Ethiopian, Bosnian, Latino, Northern European, and Native American people spread like the loose pieces of a puzzle? WING YOUNG HUIE follows the changing pattern of each dream; his photographs soak into the walls like cultural leaks. Yet the question remains: how will these infiltrations of new and old differences transform the urban space of every city willing to accept its role as global container? But mutations of cultural patterns do not arrive only from abroad or from annihilation. While open to international influences and conceptual creolization, some countries reject the idea of a contemporary society constructed around the equality of roles, where gendered hierarchies are disrupted.

kazuyo sejima and **ryue nishizawa** of **s.a.n.a.a.** approach architecture as a tool for changing the function of individuals who reside in it. Their practice aims to change the conceptual use of space in order to gain a spiritual use for the final structure. New models of a "void" might work as the invisible intellectual skeletons supporting new structures, materials, and streams of information. Finally, a place defines the presence of the individual, not as a numbered member of a complete society but as the main cell of a social organism in which architecture becomes the organ of an upgraded political and intellectual perception.

Although architecture can assume a symbolic dimension, offering a perspective not only on the space it contains but also on the archetypal memories that technology will never be able to erase, **lars spuybroek** and his office **nox** seem to relate more to the reaction of the senses when forced to confront an architecture in which corners have disappeared—hence pushing the body to a different reference system in relation to space. The body becomes the corner, in a way, both within the building and within the historical frame in which it happens to appear. Time and space now flow parallel to one another, and it's the arbitrary position of our bodies that will determine whether we are to be a part of the past or the future, while the present seems to be—as **nox** reflects in all its projects—a matter of liquid moments in transit.

Because of the disappearance of clear intersections and the fluidity of the landscape of History, we are continually less capable of defining the idea of a present. In fact, at times we feel that the present is nothing but an artificial state of mind, a scapegoat for our fear of death. But this idea of artificiality seems to be itself artificial. Are the sounds of contemporary reality artificial sounds? Is the music that's become the soundtrack of our daily existence artificial, or just another form of nature? The Finnish electronic music group **pan sonic** looks into obsolete technology—old radios and squawk boxes—to seek the origins of rhythmic diversity within the history of sound. Like the search for the point when screams turned into words and voices first came into being, the exploration of primordial music is also part of our contemporary craving for the wellspring of our expression. We are surrounded by images, but today each visual impression is paired with a much more diversified spectrum of sounds: ultrasounds or deafening sounds, romantic songs or boom-box explosions, honks, sirens and car alarms, crickets and barking dogs. **pan sonic** pushes John Cage's openness to its extreme, entering a realm where music becomes a point, a dot, or a line, a continuum of experiences like micro-traumas in our brain cells.

It's sound, then, that survives the collapse of solitude in contemporary society. Noise is eventually our proof that we are still alive amongst others—others, however, whom we might hope never to touch. As Elias Canetti wrote in his seminal study *Crowds and Power*: "It is only in a crowd that man can become free of this fear of being touched."[3] And touched we will be, surrounded by an endless parade of crowds lingering in the claustrophobic space of **andrea bowers'** slide installation *A Sense of Clear Self-evidence* (1997). Our individuality is jeopardized by the accumulation of people celebrating or revolting for or against entertainment heroes and political villains. We need the group in order to understand ourselves, our location in relation to power and eternity; alone we will misunderstand the limits of life, and we might possibly believe the most horrendous supremacies, worshipping monuments, confusing entertainment with dictatorship.

yutaka sone's marble roller coaster *Amusement* (1998) focuses on the celebration of personal satisfaction almost to the point of glorification. Yet the significance of the roller-coaster structure is that it contains within itself the potential for human annihilation. Monumental and playful at the same time,

this gigantic tool of entertainment could rapidly become obsolete and abandoned as local communities learn how to enjoy more sophisticated forms of leisure. Still, creating a monument to obsolescence means keeping in mind the moments in life when our joys appear to be infinite, surmounting physical fear and existential anguish. At that point it is basically a problem of recovering from historical diseases and the proliferation of personal losses in order to enter the wider concept that is globalization—which involves not only economic strategies and the redistribution of goods, but an anthropological mutation, an adjustment of the joint that binds us to our local dimension.

HUANG YONG PING keeps going back and forth, revising and rethinking, adjusting and tinkering with the ways that social and medical healing interconnect. *The Pharmacy* (1995–1997) is an out-of-scale gourd, similar to those that Taoist monks used to carry their traditional medicines; all around it, anonymous to Western eyes, are other fundamental ingredients used in Chinese medicine. The gourd also resembles a hand-crafted Freudian maternal abyss, a space of simultaneous loss and resurrection. The artist observes the human state from that privileged but painful point of view of someone exiled, someone who can see his own reality from a distance and, rotating like a social hologram, from the inside and outside. Curing just one region will not save the Earth; we need to take care of the whole world like a body through which we move as vital cells. Perhaps the hardest task for humankind will be to acknowledge the existence of a global psyche, a pervasive pathology in which people are the symptoms. Who knows if at one point the planet will be covered with dust, useless to itself and to us, uninhabited, a forgotten object on the universe's shelf?

Dust creates landscapes, which contain minimal traces of every particle's passage. Stories and histories are recorded in dust, invisible as long as the winds of progress don't blow them away. In her installations, KOO JEONG-A collects simple grains of memory in order to understand how a moment can be created and perceived autonomously from the flow. How do we maintain any concept of space now that moving requires neither time nor space? Koo molds the climate around the void where contemporary language floats, creating space within mental motion and static appearances. Nothing moves, but everything shifts ahead slowly, eternally, perforating goals and targets across time zones. We are sleepwalkers following a trail of optical fibers, through a world of information dust where the only force is the light.

Now some vapors are blurring the millennial horizon, things have double edges, everything seems to have its own doppelgänger. In *Neuschwansteins* (1998), JAMES ANGUS picks his hero from the irrelevance of historical madness—Ludwig II of Bavaria and his castle, an invention where the past has been seen as just another style, a fantasy to use as a stepping-stone to reach the next stage of History, where we peek into a future below. What we are looking at is a hazy fairy tale with its own double ending—tragic if greatness was the idea, playful if the idea was only to dislocate time in the memory of the next generation of descendant tourists as an unconscious premonition for that nonhistorical reality of Disneyland, where the past is treated as just a draft for a perpetual present.

Apparently, today's largest peaceful migration of people is that produced by the perennial masses of tourists moving around the world. They may be the real heroes of the future, people devoted to becoming textures of the world, a soft net or gauze that brings money and peace wherever it arrives. We have the monument to the unknown soldier, but soon we will also have one to the unknown tourist—some person collapsed under the sky of Florence or in the Burmese jungle. THOMAS SCHÜTTE's seven heroes are thus a preposterous presence in the nation of Tourism. Like the heads crowding the jungle in the Brando/Kurtz kingdom of Francis Ford Coppola's *Apocalypse Now*

(1979), the shrunken portraits in the artist's *Die glorreichen Sieben* (1992–1993) have a double-edged feeling of martyrs and executioners.

Only recently have we needed to rewrite History, erasing those paragraphs too painful to be read over and over—but wrong and right is circumstantial, some would say. *Le livre noir du communisme (The Black Book of Communism)* (1997) bluntly exposes the horrible figures of communist dictatorship in the world; nearly one hundred million people put to death, compared to the twenty-five million of the Nazi terror. But numbers are not enough to rewrite History. In fact, differences still exist, which is not an excuse but a fact: communism was a philosophical idea that pervaded the world and still does, but it has always been impossible to apply or even to realize peacefully, and probably always will be. Nazism was from the very beginning a warped fantasy based on an idea of racial supremacy, and thus wrong at its very core. That's why numbers are meaningless—and even seven heads can represent the victims of all atrocities, political or not. All of them are different from each other, as all victims are different from each other in the carnage of History, which grinds together national pride and private, excruciating sorrows.

Yet the army of History does take hostages, abandoning casualties. These prisoners are the tenants of a complex society that escaped revenge because of appealing economic partners or potential market El Dorados. The state of women in many countries is therefore that of prisoners of a past, but their condition does not instigate international sanctions or economic embargoes because the issue is not a "political" one and gender is not a popular topic in the Geneva conventions. SHIRIN NESHAT uses the weapons of creativity and mystery in her art. In her video projection *Turbulent* (1998), the voice of a woman singing in front of an empty auditorium explodes like the most deadly grenade, silencing the acclaimed male counterpart and his audience. Hers is a strength rising from the depth of the body that defeats any segregation, producing a different kind of freedom—not yet sufficient to cleanse the outrage imposed by barbaric laws, but definitely strong enough to cast a revolutionary shadow on the future of those contemporary medieval societies. Repression is hence the greatest waste of energy on the planet, because it drains both those who impose it and those who fight it.

THOMAS HIRSCHHORN's sculpture is a totem to dispersed energies in society, and an attempt to direct them toward forgotten issues, isolated zones of the mind. The Swiss army knife in his work *Spin-off* (1998) stands as a violent Shiva in the middle of European consciousness, where the philosophy of nonintervention is revealed as a tool of greediness and capital accumulation beyond morality and guilt. It is perhaps his vision to transform a country like Switzerland into Géricault's *The Raft of the Medusa* at the Louvre. THOMAS STRUTH's photograph of this Géricault painting in situ, *Musée du Louvre 4, Paris* (1989), shows a public pathetically helpless in the face of all tragedies. The viewers have no faces because they are silent witnesses and accomplices of a looting perpetrated in front of History's eyes. This is a feeling we share again and again while facing headlines in the daily paper. The Medusa is Rwanda, Cambodia, Albania, Eritrea, South Africa, Indonesia, Bosnia, Algeria, Iraq, Kosovo, Ethiopia, Afghanistan, Kurdistan, the West Bank, Northern Ireland, Nigeria, Sri Lanka, North Korea, and Burma, but the most important places are those we know nothing about because they are deprived by destiny of any economic, political, or cultural details that could produce some relevance or interest in our eyes. We grow oblivious in order to avoid madness, but before madness there is Goya's sleep of reason and its monsters.

ROMAN SIGNER's video *Bett* (1996) offers a humorous but nevertheless dramatic solution to historical and current ills. We sleep in a bed (our reality) in an empty room (the world), as a menacing model

helicopter flies dangerously close to our heads. Is History the noise outside or the dream within our unconsciousness? Maybe both, or maybe neither. We want History to measure up to our desire for newness, but how can we introduce newness without annoying the poltergeist of Time? It is a symbolic voice, that of Salman Rushdie, which gives us a possible answer: "The *Satanic Verses* celebrates hybridity, impurity, intermingling, the transformation that comes of new and unexpected combinations of human beings, cultures, ideas, politics, movies, and songs. It rejoices in mongrelization and fears the absolutism of the pure. Melange, hotchpotch, a bit of this and a bit of that is how the newness enters the world."[4]

History, as a business, is now finished, at least the one written from left to right, or top to bottom, or right to left. The next one will be written by a community of peaceful mongrels, not us. It will be written in a new language, a language that will start from the bottom to reach, like a pillar, to the top. A contemporary argot, this dialect was described by Victor Hugo in *Les Misérables* as "the language of misery" or "the language that misery invented to fight" or "the language of those who live in the darkness." Western civilization will have to learn the argot of the next century in order to survive the huge wave of time ready to submerge it and sink it to "the bottom of that ocean we call the past." It will be our capacity to become the most sophisticated translators that will allow us to comprehend the meaning and not just the sound of the multilayered dialect of the future. As Walter Benjamin wrote, "For to some degree all great texts contain their potential translation between the lines: this is true to the highest degree of sacred writing."[5]

Maybe it is not a blasphemous idea to add Art to the list of those sacred scriptures. If so, this contemporary esperanto of expressions and ideas will lift us up just slightly in order to observe the landscape of History divided unevenly by the river of Time and its tributaries. From above, History appears as the continuous movement of people, animals, waves, winds, and rains converging into each other, crashing, entering into those growths on the hurt skin of the Earth that cities and suburbs are. If we just watch them, it is impossible to say that all of this action is in some way nearing that which we call the end or the beginning of a century. What is changing today are not the dates of the calendar but the voices that are moving from language to argot. This is what constitutes the noise we hear from above. We cannot understand if those floating masses of people are armies or tourists, prisoners in a stadium or teenagers at a rock concert. Only their language makes them different from one another.

1. Edward Behr. *Anyone here been raped & speaks English?* (New York: Viking Press, 1978).
2. *Dazibaos*, or literally "big character posters," were used during the Chinese Cultural Revolution (1966–1969) to publicly address political and cultural issues.
3. Elias Canetti. *Crowds and Power* (New York: The Seabury Press, 1978), p. 15.
4. Salman Rushdie. "In Good Faith" (1990) in *Imaginary Homelands: Essays and Criticism 1981–1991* (London: Granta, 1991), p. 394.
5. Walter Benjamin. "The Task of the Translator" (1923) in *Illuminations*, Hannah Arendt, ed. (New York: Schocken,1969), p. 82.

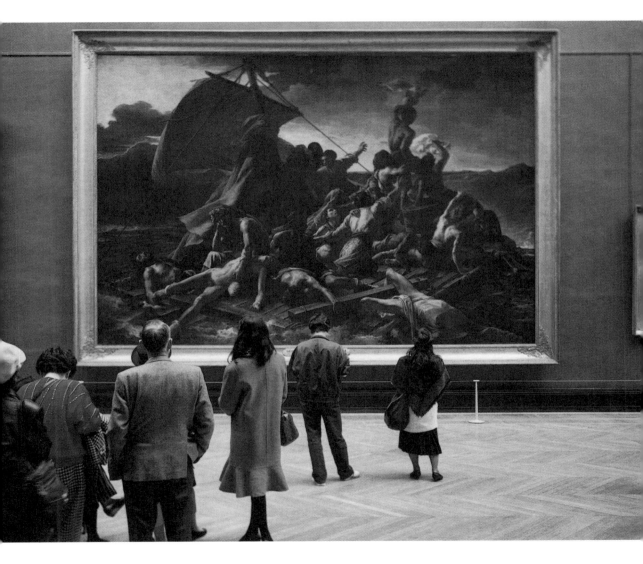

Thomas Struth *Musée du Louvre 4, Paris* 1989
C-print; edition 4 of 10
Marieluise Hessel Collection on permanent loan to the Center for Curatorial Studies,
Bard College, Annandale-on-Hudson, New York

Maurizio Cattelan
Novecento (Twentieth Century) 1997
(installation view at Castello di
Rivoli–Museo d'Arte Contemporanea)
taxidermic horse
Collection Castello di Rivoli–Museo d'Arte
Contemporanea, Rivoli (TO), Italy

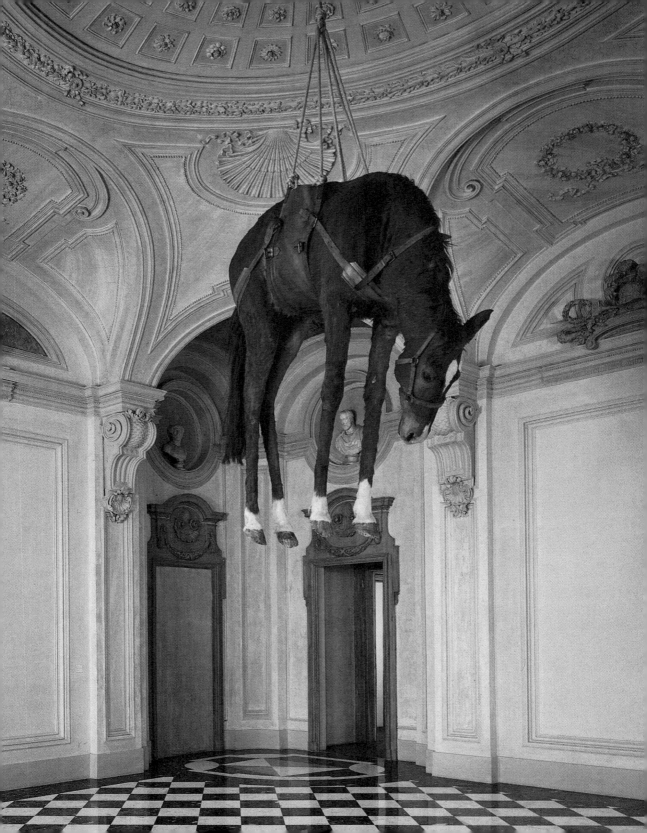

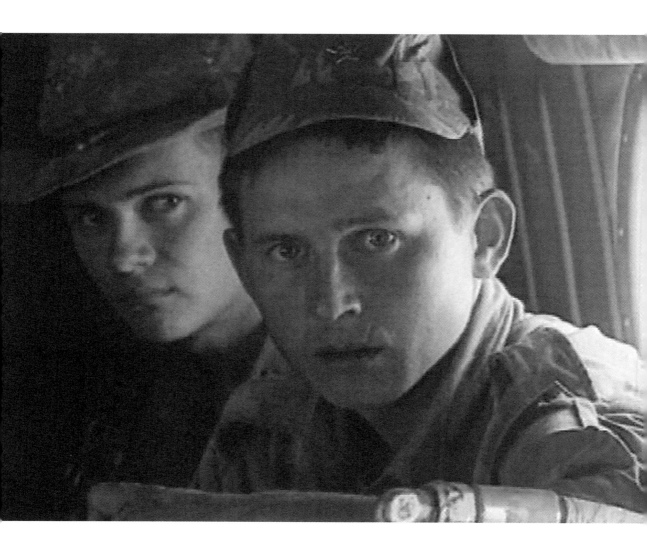

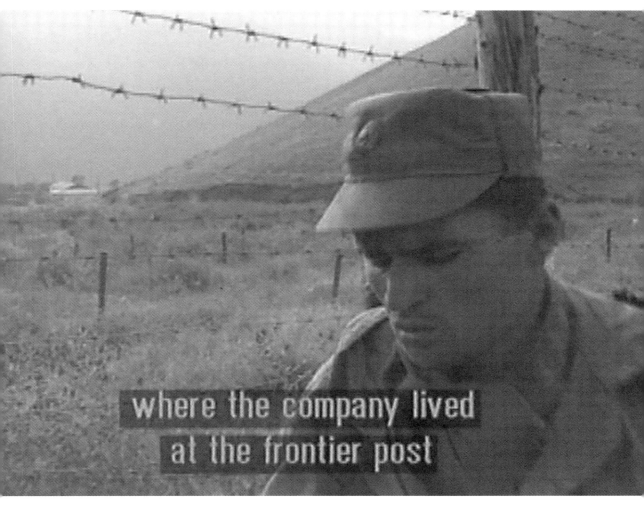

where the company lived
at the frontier post

Alexandr Sokurov *Spiritual Voices (Dukhovnye golosa)* 1995 (video stills)
single-channel videotape
Courtesy the artist and zero film Gmbh, Berlin

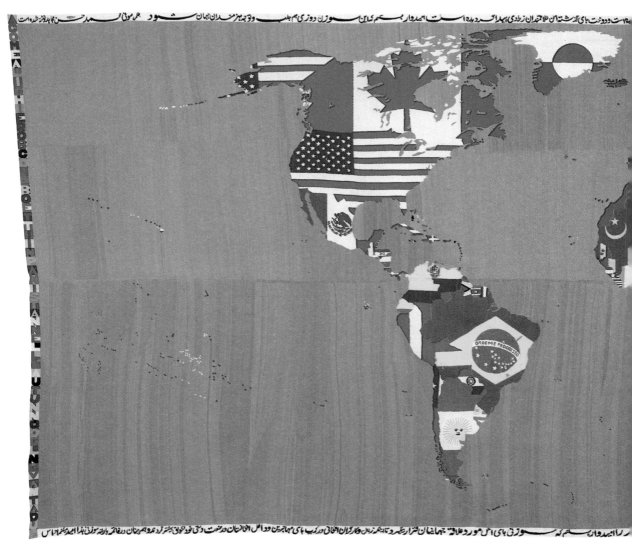

Alighiero Boetti *Mappa* 1992–1993
hand embroidery on cotton
Collection Giordano Boetti, Rome

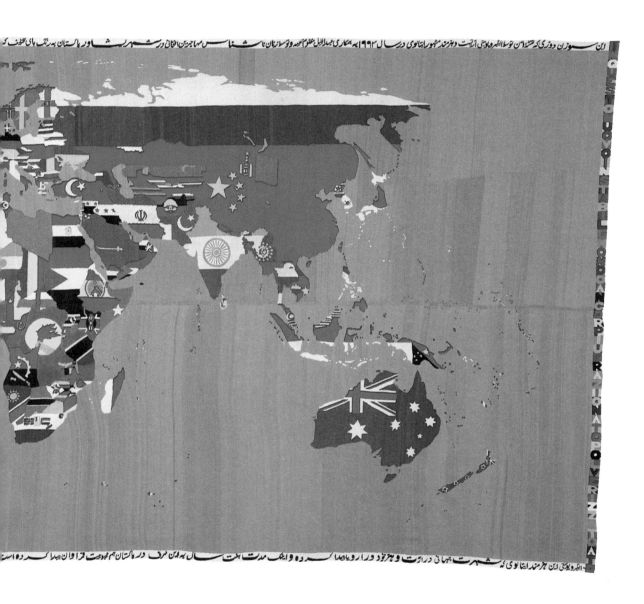

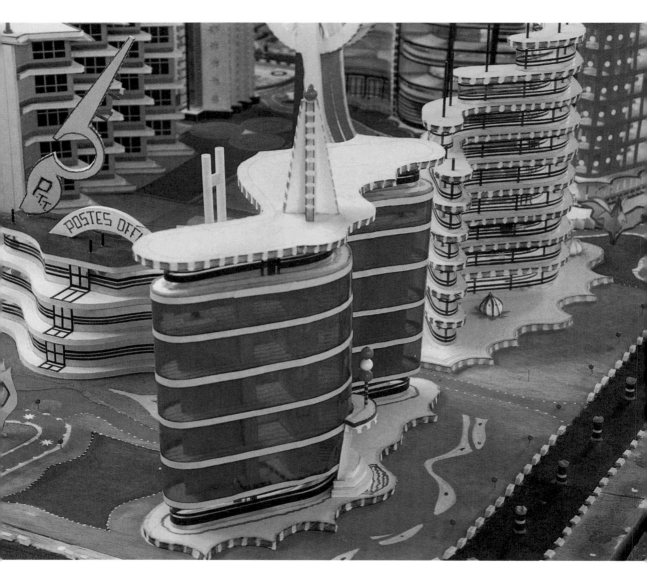

Bodys Isek Kingelez *Ville Fantôme* 1996 (details)
paper, plastic, cardboard
C.A.A.C.–The Pigozzi Collection, Geneva

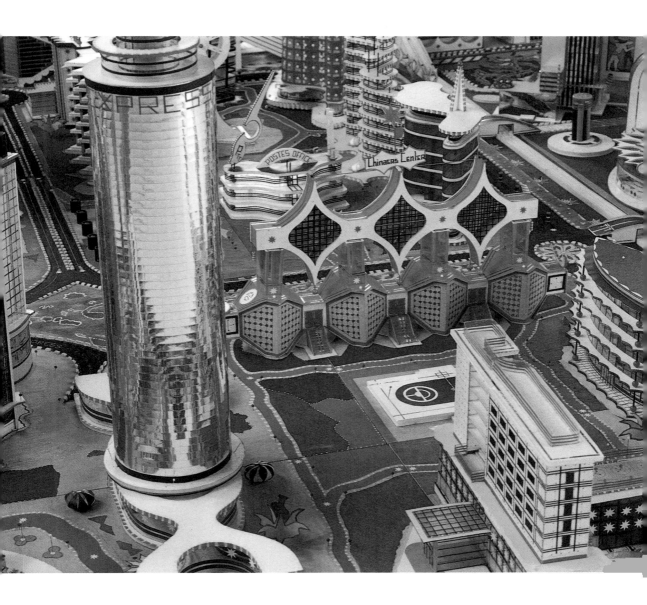

Gabriel Orozco *Kitchen Door Maze* 1997 (details)
fiberboard, wood, wired glass, hinges, paint, eleven drawings
Courtesy the artist and Anthony D'Offay Gallery, London

Gabriel Orozco *Kitchen Door Maze* 1997 (detail)
fiberboard, wood, wired glass, hinges, paint, eleven drawings
Courtesy the artist and Anthony D'Offay Gallery, London

Gabriel Orozco *Isla en la Isla (Island within an Island)* 1993
cibachrome print
Collection Walker Art Center, Minneapolis
T. B. Walker Acquisition Fund, 1996

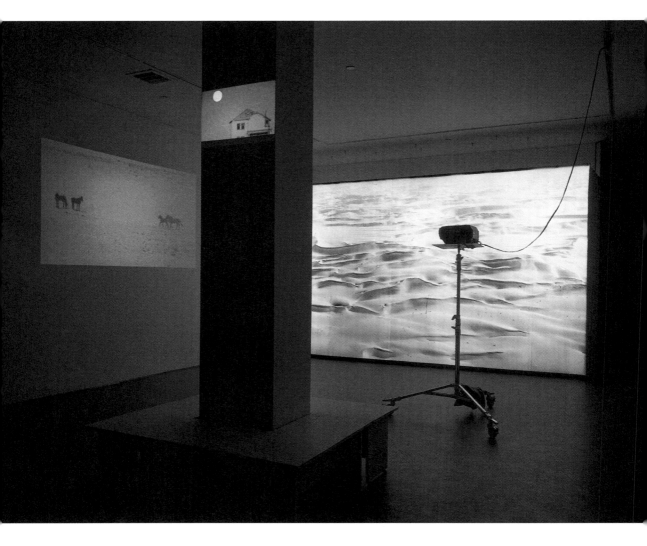

Doug Aitken *Diamond Sea* 1997
(installation view at 303 Gallery, New York, above, and production still)
video projection, laserdisc
Collection Walker Art Center, Minneapolis
Justin Smith Purchase Fund, 1997

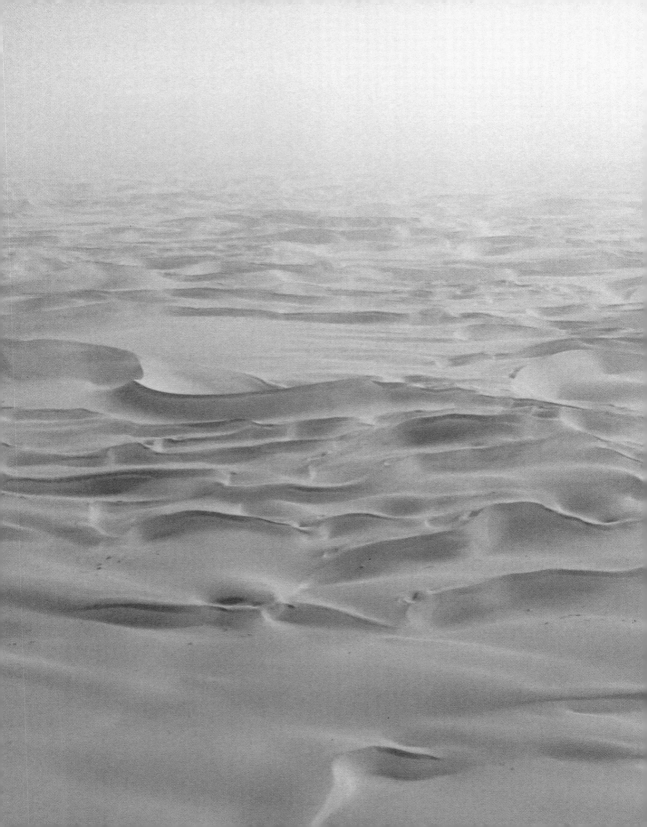

Doug Aitken *Diamond Sea* 1997
(production still)
video projection, laserdisc
Collection Walker Art Center, Minneapolis
Justin Smith Purchase Fund, 1997

William Kentridge *Ubu Tells the Truth* 1997 (details)
video projection, laserdisc
Courtesy the artist, Johannesburg

overleaf: **William Kentridge** *Ubu and the Truth Commission,* 1997
(still from the theater production)
Courtesy the artist, Johannesburg

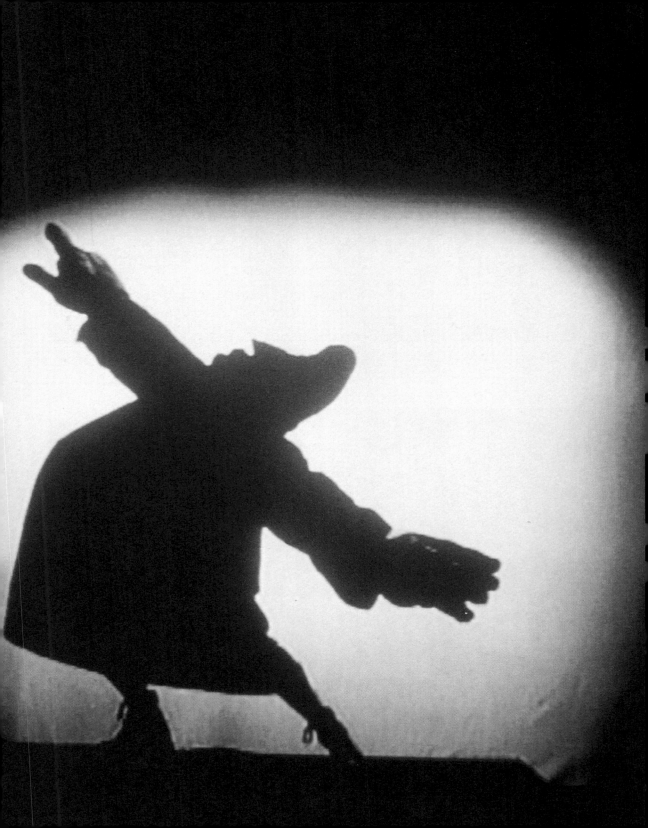

Mats Hjelm *White Flight* 1997 (video stills)
video projection, two laserdiscs
Courtesy the artist and Galleri Index, Stockholm

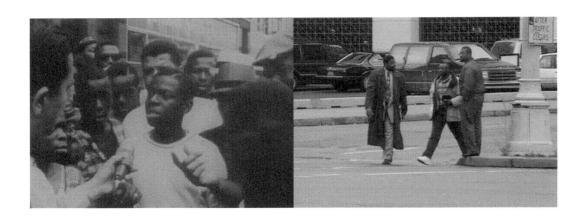

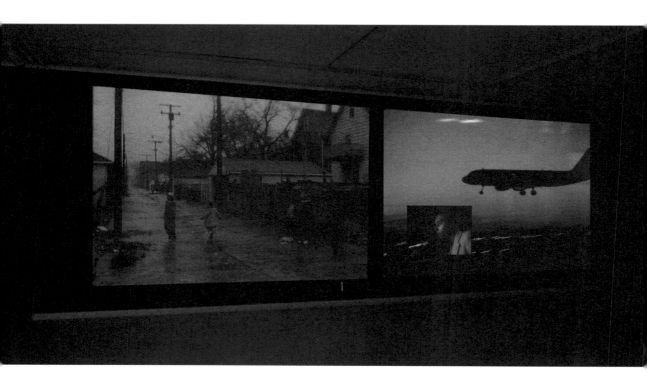

Mats Hjelm *White Flight* 1997 (installation views)
video projection, two laserdiscs
Courtesy the artist and Galleri Index, Stockholm

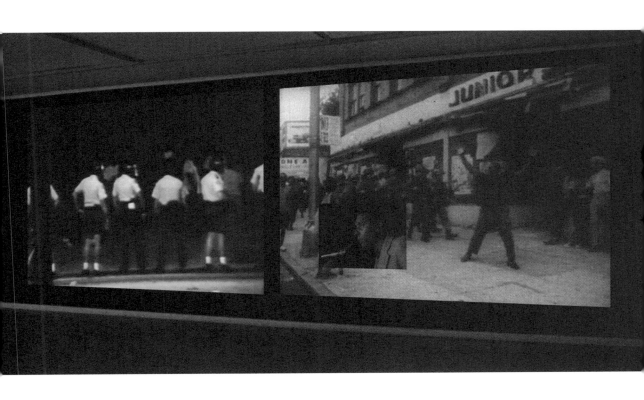

Cady Noland *SLA Group Shot #1* 1991
black silkscreen on aluminum
Courtesy the artist, New York

right: **Cady Noland** *Oozewald* 1989
black silkscreen on metal, flag
Courtesy the artist, New York, with original
photograph courtesy Bob Jackson

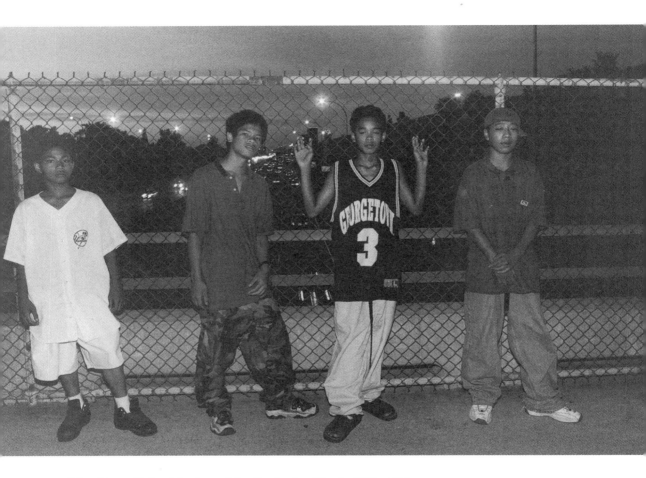

Wing Young Huie *Members of the Cambodian Bloods, 1998* 1998
black-and-white photograph
Courtesy the artist, Minneapolis

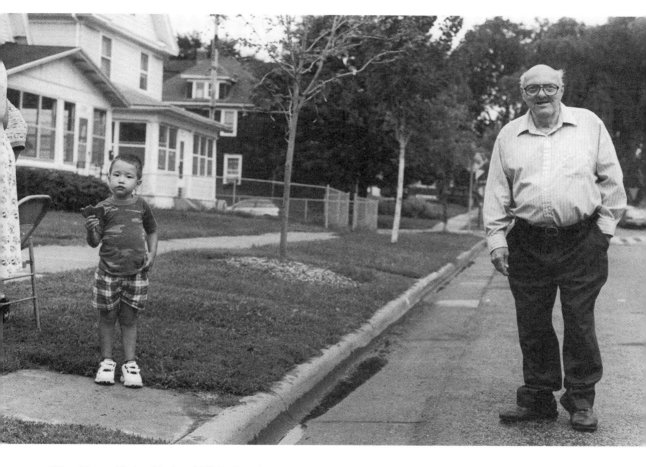

Wing Young Huie *National Night Out, Powderhorn Park, 1997* 1997
black-and-white photograph
Courtesy the artist, Minneapolis

overleaf: **Wing Young Huie**
High School Graduation Party, Lake Street, 1997 1997
black-and-white photograph
Courtesy the artist, Minneapolis

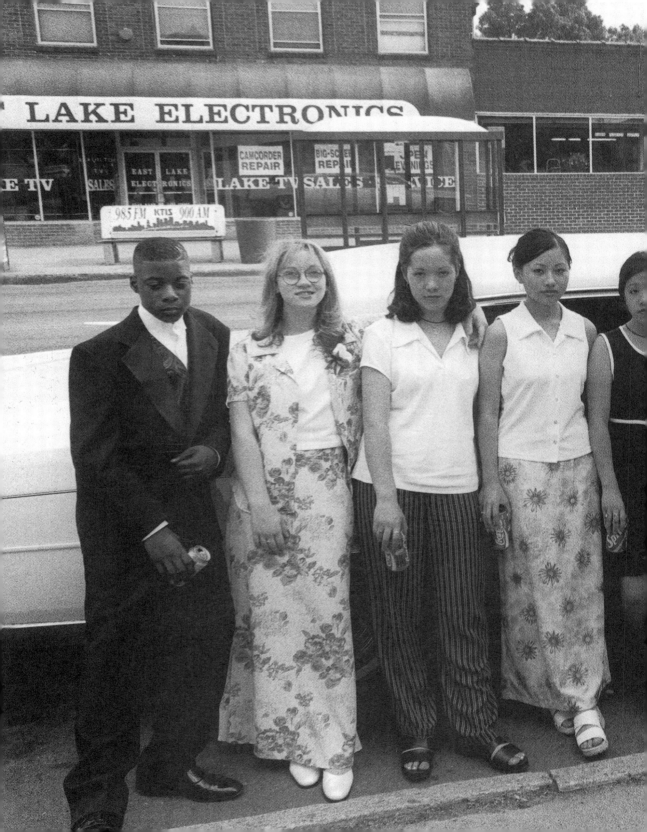

S.A.N.A.A. (Kazuyo Sejima and Ryue Nishizawa & Associates)
Model for *The Richard H. Driehaus International Design Competition
for IIT Campus Center* 1998 (detail)
acrylic, polycarbonate
Courtesy S.A.N.A.A. Ltd., Tokyo

NOX (Lars Spuybroek) *NearDeathHotel* 1998 (detail)
color photomural
Courtesy NOX, Rotterdam

Andrea Bowers
A Sense of Clear Self-evidence 1997
(installation view)
slides, slide projectors, mirrors
Courtesy the artist, Los Angeles

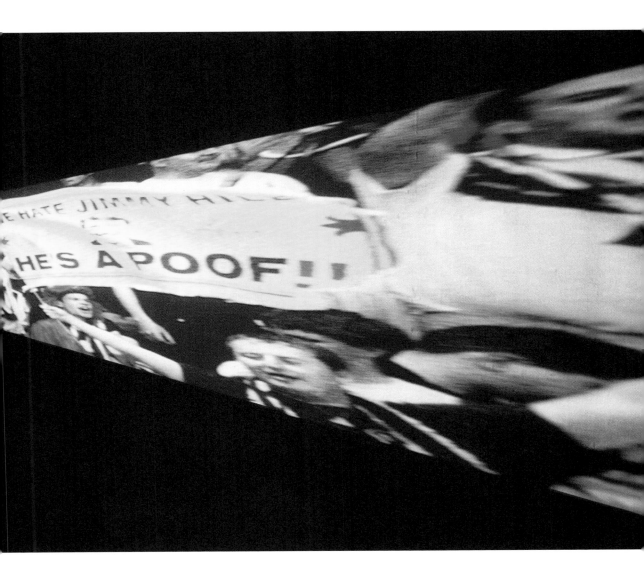

Andrea Bowers
A Sense of Clear Self-evidence 1997
(artist's compilation of images)
Courtesy the artist, Los Angeles

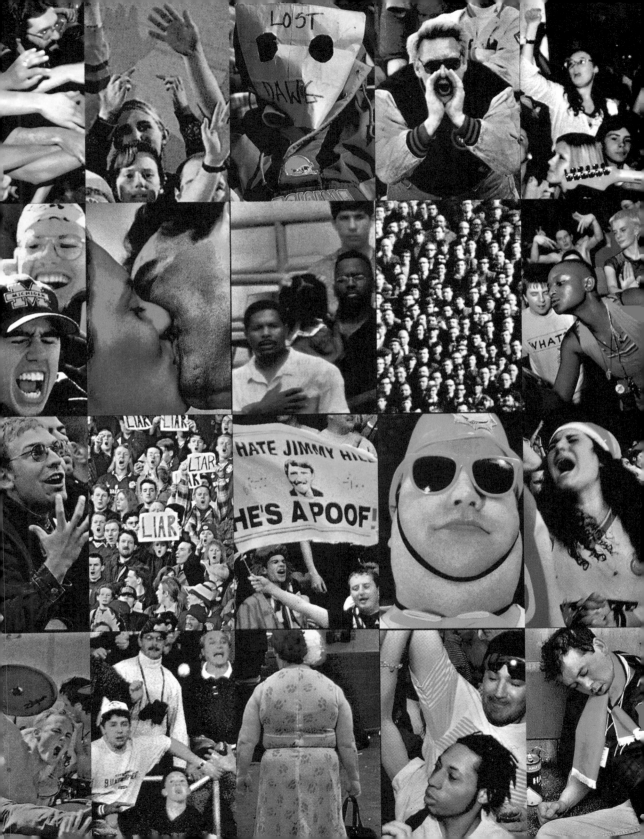

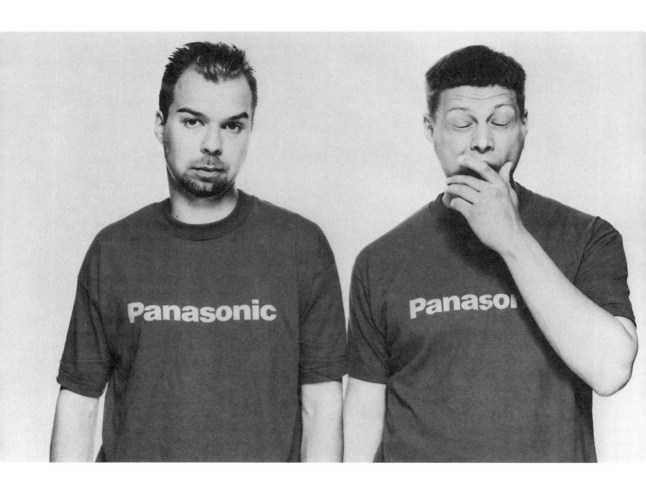

Pan Sonic (Mika Vainio and Ilpo Väisänen)
Photo courtesy Blast First UK, London

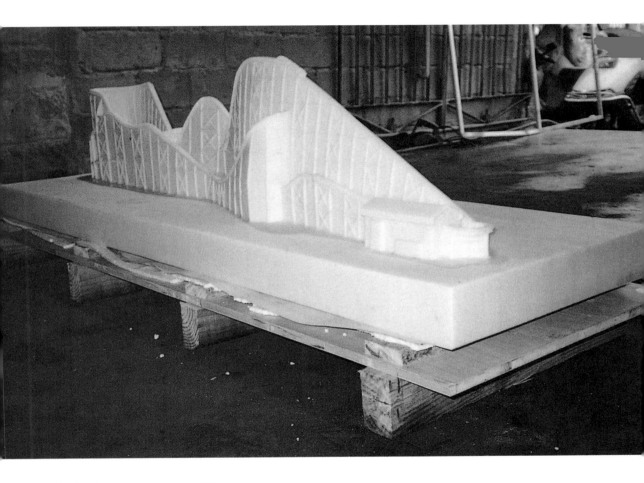

Yutaka Sone *Amusement* 1998
(at factory in Wufeng, China)
marble
Courtesy the artist and David Zwirner Gallery, New York

overleaf: **Huang Yong Ping** *The Pharmacy* 1995–1997
mixed-media installation
Courtesy the artist and Jack Tilton Gallery, New York

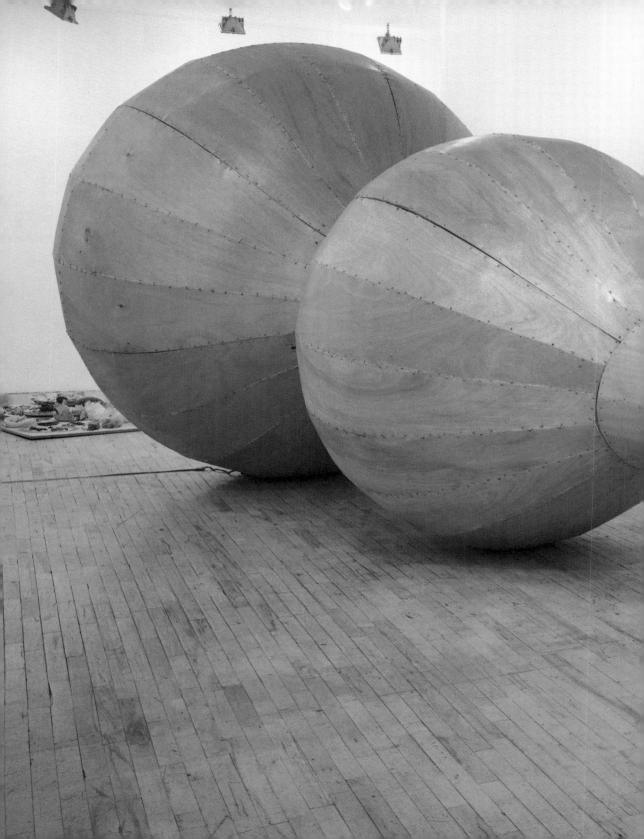

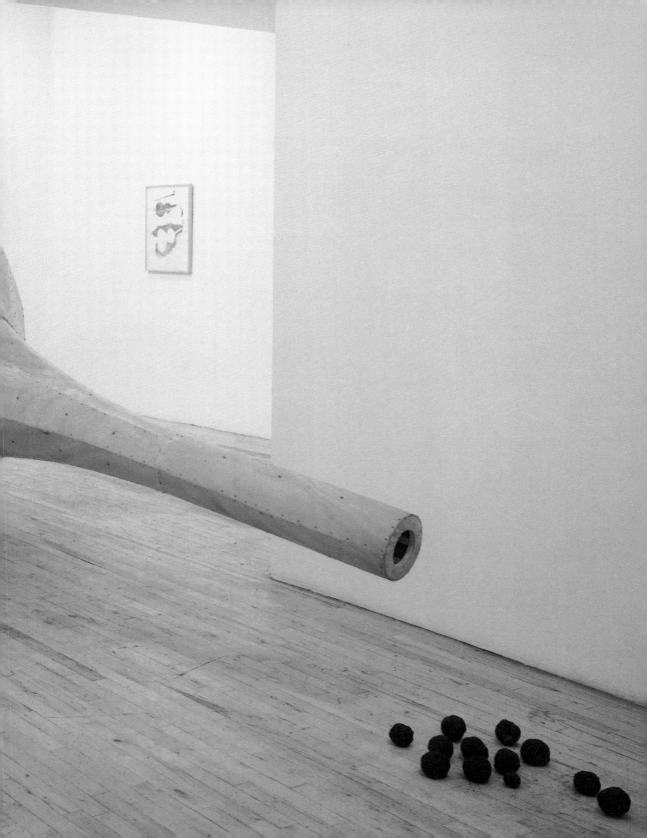

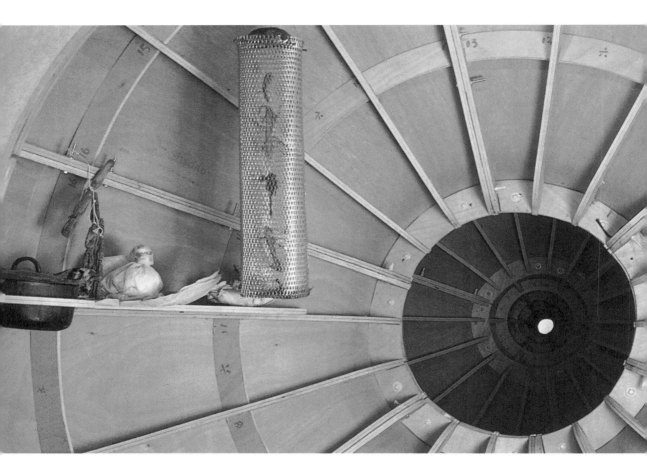

Huang Yong Ping *The Pharmacy* 1995–1997 (details)
mixed-media installation
Courtesy the artist and Jack Tilton Gallery, New York

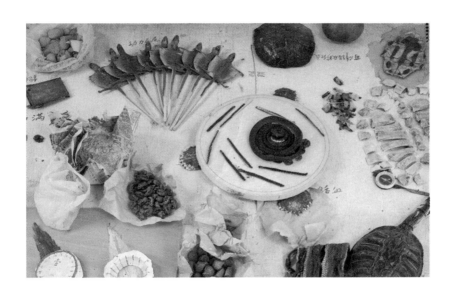

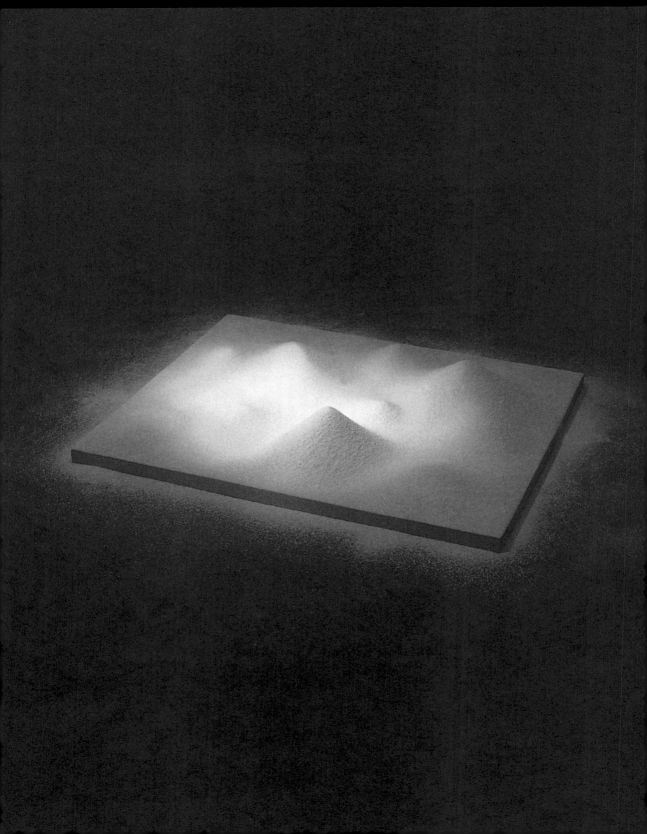

Dear Francesco,

Thanks alot for your message.
I found the word at last for the idea that I told
you about.
Gilles Deleuze once said that life is immanence.
I'm thinking about an immanential corner.
I'll tell you one more idea for the piece.
I'll be making some bumps in the space of the corner
with paper paste.
It will be a veil in a three-dimensional method.

More than a writer and idea maker.
More than a Situationist.
My dream land.

Koo Jeong-a

Koo Jeong-a *hùmpty-dùmpty* 1998
study for site-specific installation at Walker Art Center, Minneapolis
Courtesy the artist, Paris

left: **Koo Jeong-a** *Oslo* 1998
aspirin, spotlight
Courtesy the artist and Barbara Gladstone Gallery, New York

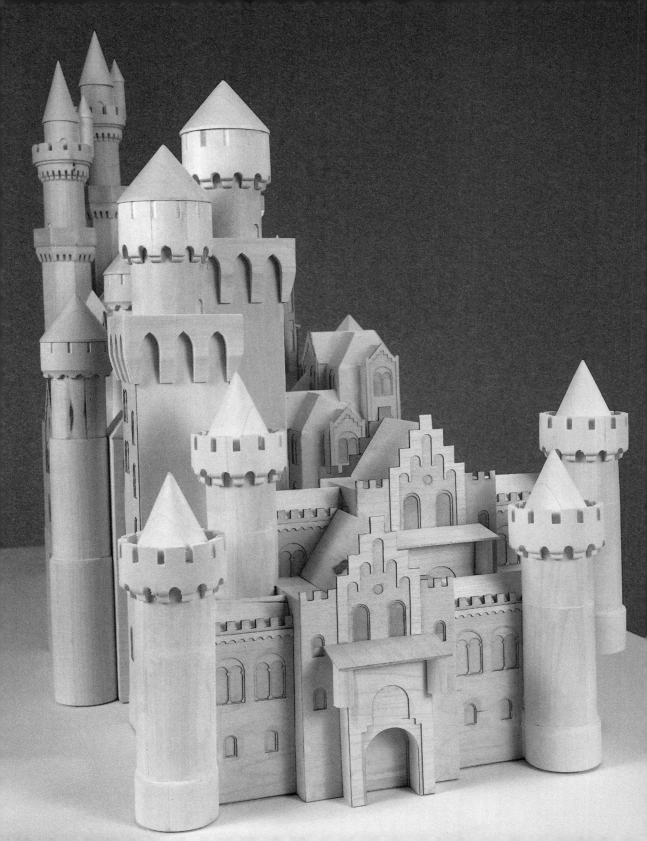

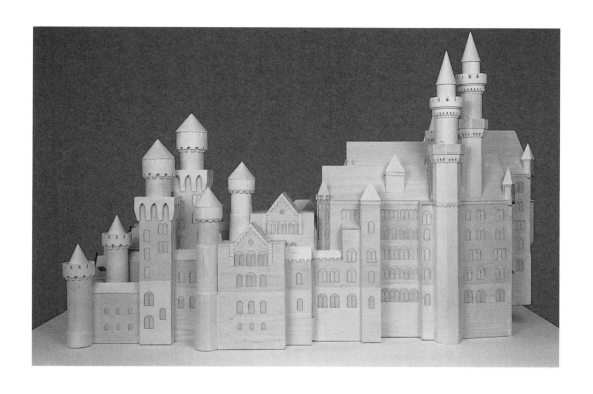

James Angus *Neuschwansteins* 1998
wood
Courtesy the artist and Gavin Brown's enterprise, New York

Thomas Schütte
Die glorreichen Sieben 1992–1993 (details)
ceramic heads on steel pedestals
Collection Rachel and Jean-Pierre Lehmann, New York

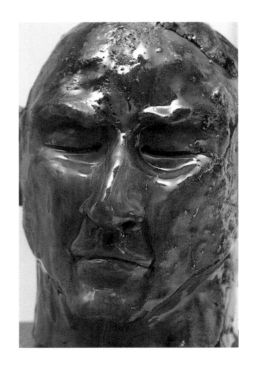

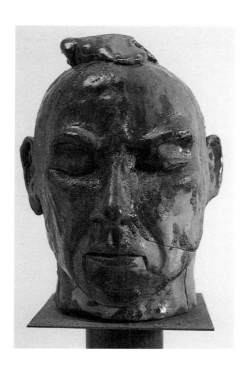
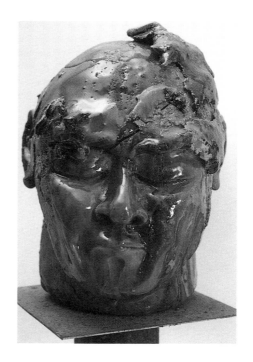

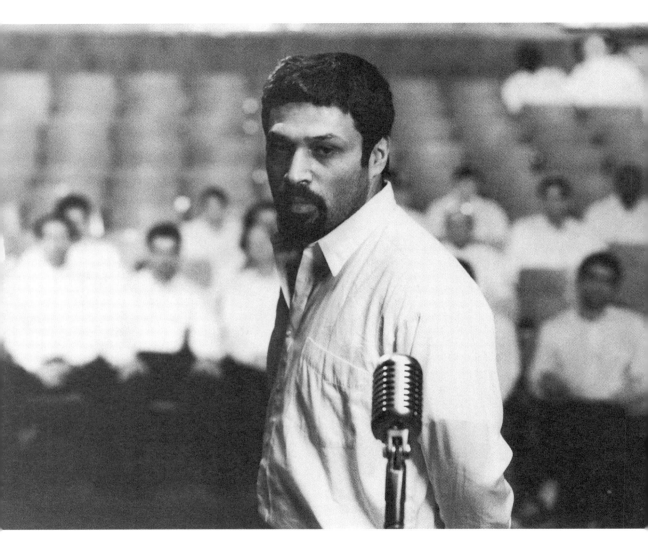

Shirin Neshat *Turbulent* 1998 (production stills)
video projection with two laserdiscs
Collection Camille Hoffmann, Naperville, Illinois

overleaf: **Thomas Hirschhorn** *Spin-off* 1998 (detail)
mixed-media installation
Courtesy the artist and Niklas Svennung Gallery, New York

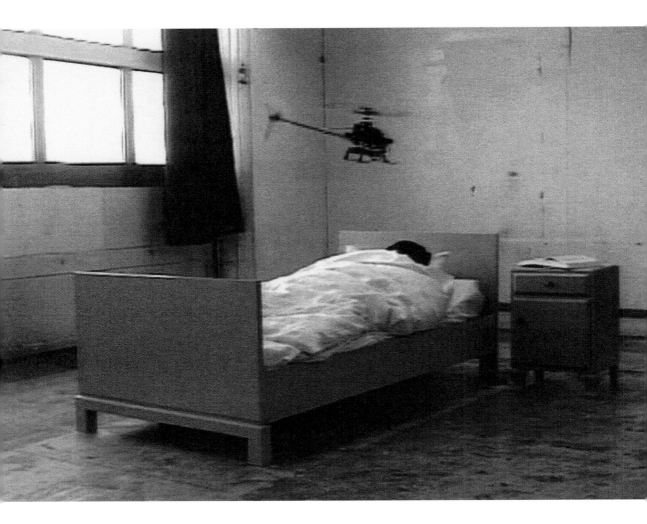

Roman Signer *Bett* 1996 (video still)
single-channel videotape transferred to laserdisc
Collection Walker Art Center, Minneapolis
Art Center Acquisition Fund, 1998

DOUG aITKen

Doug Aitken was born in Redondo Beach, California, in 1968. He currently lives and works in Los Angeles. His first solo exhibition took place at AC Project Room in New York in 1994. Since then he has had solo exhibitions at Taka Ishi Gallery in Tokyo (1996), 303 Gallery in New York (1997), and most recently at Jiri Svestka Gallery in Prague (1998). His work has also appeared in a number of group exhibitions, including the *1997 Biennial Exhibition* at the Whitney Museum of American Art in New York (catalogue) and *film+arc.graz* at the *Third International Biennale* in Graz, Austria (catalogue) (both in 1997), *L.A. Times* at Palazzo Re Rebaudengo in Guarene, Italy (catalogue) (1998). His films and videos have also appeared in numerous international festivals, including the Telluride Film Festival (1995), The New York Film Festival (1996), The New York Video Festival (1996), and the Rotterdam International Film Festival (1998).

James anGus

James Angus was born in Perth, Australia, in 1970. He currently lives and works in New York. His first solo exhibition took place at the Perth Institute of Contemporary Arts in 1991. His most recent solo exhibition was held at Gavin Brown's enterprise in New York (1997). His work has also been shown in a number of group exhibitions, including the *Adelaide Biennial of Australian Art* at the Art Gallery of South Australia (catalogue) and *Transformers* at the Auckland City Art Gallery in New Zealand (both in 1996), and *Fischli and Weiss, Hans Accola, and James Angus* at Gavin Brown's enterprise in New York (1997).

aLIGHIeRO BOeTTI

Alighiero Boetti was born in Turin, Italy, in 1940. He died in Rome in 1994. Associated over the course of his career with the Italian Arte Povera artists, his first solo exhibiton took place at Gallery Christian Stein in Turin in 1967. Showing extensively over the course of the next three decades, he was the subject of a retrospective exhibition, *Alighiero Boetti* at the Galleria Civica d'Arte Moderna e Contemporanea in Turin (catalogue) (1996). Most recently his work appeared in the exhibition *Alighiero Boetti: Mettere al mondo il mondo* at the Museums für Moderne Kunst and the Galerie Jahrhunderthalle Hoechst in Frankfurt (catalogue) (1998). His work has also recently appeared in a number of international group exhibitions, including *Worlds Envisioned* at the Dia Center for the Arts in New York (catalogue), *The Italian Metamorphosis, 1943–1968* at the Solomon R. Guggenheim Museum in New York (catalogue), and *Mapping* at The Museum of Modern Art in New York (catalogue) (all in 1994), the *Tenth Biennale of Sydney* in Australia (catalogue) (1996), *Skulptur Projekte in Münster*, Germany (catalogue), and *Arte Povera: Arbeiten und Dokumente aus der Sammlung Goetz, 1958 bis heute* at the Sammlung Goetz in Munich (catalogue) (all in 1997), *Terra Incognita, Five Visionary Worlds: Alighiero e Boetti, Vija Celmins, Neil Jenney, Jean-Luc Mylayne, Hiroshi Sugimoto* at the Neues Museum Weserburg in Bremen, Germany (catalogue) and *Alighiero Boetti, Nicola de Maria, Mimmo Paladino* at the Galleria Cardi in Milan (both in 1998).

anDRea BOWeRS

Andrea Bowers was born in Wilmington, Ohio, in 1965. She currently lives and works in Los Angeles. Her first solo exhibition took place at the California Institute of the Arts in Valencia, California, in 1991. Most recently she has exhibited at the Santa Monica Museum of Art in Santa Monica, California (1998). Her work has also appeared in a number of group exhibitions, including *Hot Coffee* at Artists Space in New York (1997), *1998 Phoenix Triennial* at the Phoenix Art Museum in Phoenix, Arizona, and *Guarene Arte '98* at the Fondazione Sandretto Re Rebaudengo in Guarene, Italy (catalogue) (both in 1998).

mauRIZIO CaTTeLan

Maurizio Cattelan was born in Padova, Italy, in 1960. He currently lives and works in Milan, Paris, and New York. His first solo exhibition took place at Galleria Neon in Bologna, Italy, in 1989 (catalogue). Most recently he has exhibited his work in solo exhibitions at the Castello di Rivoli in Torino, Italy (catalogue), Galleria Massimo Minini in Brescia, Italy, and the Wiener Secession in Vienna (catalogue) (all in 1997). His work has appeared in a wide array of international group exhibitions, including *Aperto 93* at the *XLV Venice Biennale* (catalogue) (1993), the *95 Kwangju Biennale: Beyond the Borders* in South Korea (catalogue) (1995), the Italian Pavilion at the *XLVII Venice Biennale* (catalogue), *Skulptur Projekte in Münster*, Germany (catalogue), *Truce: Echoes of Art in an Age of Endless Conclusions* at SITE Sante Fe in New Mexico (catalogue), the *International Istanbul Biennial* in Turkey (catalogue) (all in 1997), and *Manifesta 2* in Luxembourgh (catalogue) (1998).

THOmas HIRSCHHORn

Thomas Hirschhorn was born in Bern, Switzerland, in 1957. He currently lives and works in Paris. His first solo exhibition took place at Bar Floréal in Paris in 1986. He has recently been the subject of a number of one-person exhibitions at a wide range of galleries and institutions, including Niklas Svennung Gallery in New York, Kunsthalle Bern (catalogue), the Ludwig Museum Cologne in Germany (catalogue), The Herzliya Museum of Art in Israel, and Portikus in Frankfurt (catalogue) (all in 1998). His work has also appeared in a number of international group exhibitions, including *Africus: Johannesburg Biennale (1st: 1995)* in South Africa (catalogue) (1995), *Skupltur Projekte in*

Münster, Germany (catalogue) (1997), and *Art from France* at the Solomon R. Guggenheim Museum in New York (catalogue) (1998).

mats Hjelm

Mats Hjelm was born in Stockholm, Sweden, in 1959. He currently lives and works in Stockholm. His first solo exhibition took place at the Kalmar Art Museum in Sweden in 1989. He has recently exhibited his work in one-person exhibitions at Galleri Index in Stockholm (1997) and Gallery Kari Kenetti in Helsinki, Finland (1998). His work has appeared in a number of group exhibitions, including *Breaking Eyes* at the Färgfabriken Art Center in Stockholm and the Nordic Art Center in Helsinki (1996), *Delta* at the Musée d'Art Moderne de la Ville de Paris (catalogue) and *Ny Nordisk konst i moderna bildmedia* at the Kalmar Art Museum in Sweden (both in 1997), and *Central Station Art Park* in Stockholm (1998).

Huang Yong Ping

Huang Yong Ping was born in Xiamen, China, in 1954. He currently lives and works in Paris. His first solo exhibition was held at L'École des Beaux-Arts d'Aix-en-Provence, France, in 1990. He has recently had a number of one-person exhibitions at Fondation Cartier pour l'Art Contemporain in Paris, De Appel in Amsterdam (catalogue), Art & Public in Geneva, and Jack Tilton Gallery in New York (all in 1997). His work has also appeared in a number of international group exhibitions, including *Magiciens de la Terre* at the Centre Georges Pompidou and Grande Halle de la Villette in Paris (catalogue) (1989), *Manifesta 1* in Rotterdam, The Netherlands (catalogue) (1996), the *97 Kwangju Biennale: Unmapping the Earth* in South Korea (catalogue), *Trade Routes, History and Geography: 2nd Johannesburg Biennale 1997* in South Africa (catalogue), *Cities on the Move* at the Wiener Secession in Vienna (catalogue), *Skulptur Projekte in Münster*, Germany (catalogue), *Truce: Echoes of Art in an Age of Endless Conclusion* at SITE Santa Fe in New Mexico (catalogue) (all in 1997), and *The Hugo Boss Prize* at the Guggenheim Museum Soho in New York (catalogue) (1998).

Wing Young Huie

Wing Young Huie was born in Duluth, Minnesota, in 1955. He currently lives and works in Minneapolis, Minnesota. His first solo exhibition, *Frogtown: Portrait of a Community in an Urban Neighborhood*, took place at the Minnesota History Center in St. Paul, Minnesota, in 1995. He has recently been the subject of a one-person exhibition at the Boliou Hall Gallery at Carleton College in Northfield, Minnesota (1998). His work has appeared in a number of group exhibitions, including *Photography & Community* at the Asian American Arts Center in New

York (1994), *Small World: Images of Children* at Thomas Barry Fine Arts in Minneapolis (1997), and *Face Value* at the Minneapolis College of Art and Design Gallery in Minneapolis (1998). His first book, *Frogtown: Photographs and Conversations in an Urban Neighborhood*, was published by the Minnesota Historical Society Press in 1996.

William Kentridge

William Kentridge was born in Johannesburg, South Africa, in 1955. He currently lives and works in Johannesburg. His first solo exhibition took place at the Market Gallery in Johannesburg in 1979. He has recently exhibited his work in one-person exhibitions at The Drawing Center in New York, the Museum of Contemporary Art, San Diego, and the Palais des Beaux-Arts in Brussels, Belgium (catalogue) (all in 1998). His work has also appeared in a number of international group exhibitions, including *Documenta X* in Kassel, Germany (catalogue), *6th Havana Biennale* at the Centro Wilfredo Lam in Cuba (catalogue), *Truce: Echoes of Art in an Age of Endless Conclusions* at SITE Santa Fe in New Mexico (catalogue), *Trade Routes, History and Geography: 2nd Johannesburg Biennale 1997* in South Africa (catalogue), and *Delta* at the Musée d'Art Moderne de la Ville de Paris (catalogue) (all in 1997), *Vertical Time* at Barbara Gladstone Gallery in New York, and *The Hugo Boss Prize* at the Guggenheim Museum Soho in New York (catalogue) (both in 1998). He is also a director and designer of numerous international theater productions, including, most recently, the production *Ubu and the Truth Commission* (1997).

Bodys Isek Kingelez

Bodys Isek Kingelez was born in Kimbembele-Ihunga, Zaire, in 1948. He currently lives and works in Kinshasa, The Republic of Congo. His first solo exhibition took place at Haus der Kulturen der Welt in Berlin in 1992. Most recently his work has been seen in one-person exhibitions at the Fondation Cartier pour l'Art Contemporain in Paris (catalogue) (1995) and the Musée d'Art Moderne et Contemporain in Geneva (1996). His work has also appeared in a number of international group exhibitions, including *Magiciens de la Terre* at the Centre Georges Pompidou et Grande Halle de la Villette in Paris (catalogue) (1989), *Out of Africa* at the Saatchi Gallery in London (1992), *Cocido y Crudo* at the Museum Nacional Centro de Arte Reina Sofía in Madrid (catalogue) (1994), *Projects 59: Architecture as Metaphor* at The Museum of Modern Art in New York, the *97 Kwangju Biennale: Unmapping the Earth* in South Korea (catalogue), and *Trade Routes, History and Geography: 2nd Johannesburg Biennale 1997* in South Africa (catalogue) (all in 1997).

Koo Jeong-a

Koo Jeong-a was born in Seoul, South Korea, in 1967. She currently lives and works in Paris. Her first solo exhibition took place at Galerie Anne de Villepoix in Paris in 1995. She has also shown most recently in the one-person exhibitions *Aqueduc* at the Musée d'Art Moderne de la Ville de Paris (catalogue), *too://www.so.up/there* at 28 rue Rousselet in Paris (catalogue), and *In Out Up Down* at Casco Space in Utrecht, The Netherlands (all in 1997). Her work has also appeared in a number of international group exhibitions, including *Manifesta 1* in Rotterdam, The Netherlands (catalogue) (1996), the *97 Kwangju Biennale: Unmapping the Earth* in South Korea (catalogue) and *Cities on the Move* at the Wiener Secession in Vienna (catalogue) (both in 1997), and *Vertical Time* at Barbara Gladstone Gallery in New York (1998).

Shirin Neshat

Shirin Neshat was born in Qazvin, Iran, in 1957. She currently lives and works in New York. Her first solo exhibition took place at Franklin Furnace in New York in 1993. She has recently appeared in a number of one-person exhibitions at the Museum of Modern Art in Ljubljana, Slovenia (catalogue) and Annina Nosei Gallery in New York (catalogue) (both in 1997), the Museo Bagatti Valescchi in Milan, the Musée Européen de la Photographie in Paris, Marco Noire Contemporary Art in Madrid, and Thomas Rehbein Gallery in Cologne, Germany (all in 1998). Her work has also appeared in a number of international group exhibitions, including *Campo '95* at the *XLVI Venice Biennale* (catalogue), *Orientation* at the *International Istanbul Biennial* in Turkey (catalogue) (both in 1995), *Trade Routes, History and Geography: 2nd Johannesburg Biennale 1997* in South Africa (catalogue), *International Istanbul Biennial* in Turkey (catalogue) (both in 1997), and *Turbulence* at the Roman Theatre of Sagunto in Valencia, Spain (1998).

Cady Noland

Cady Noland was born in Washington, D.C., in 1956. She currently lives and works in New York. Her first solo exhibition took place at White Columns in New York in 1988. She has had a number of other one-person exhibitions at a variety of galleries and institutions, including Anthony Reynolds Gallery in London and American Fine Arts in New York (both in 1989), Paula Cooper Gallery in New York (1994), the Museum Boimans-van Beuningen in Rotterdam, The Netherlands (1995), and The Wadsworth Atheneum in Hartford, Connecticut (1996). Her work has appeared in a number of international group exhibitions, including *Aperto* at the *XLIV Venice Biennale* (catalogue) (1990,) the *1991 Biennial Exhibition* at the Whitney Museum of American Art in New York, (catalogue), *Documenta IX* in Kassel, Germany (catalogue), and *Post Human*, FAE Musée d'Art Contemporain, Pully, in Lausanne, Switzerland (catalogue) (all in 1992), *Selections from the Permanent Collection* at the San Francisco Museum of Modern Art and *The American Vernacular* at the Museum of Contemporary Art in Los Angeles (both in 1998).

NOX (Lars Spuybroek)

Lars Spuybroek was born in Rotterdam, The Netherlands, in 1959. He currently lives and works in Rotterdam. Spuybroek is an architect and one of the founders of NOX Architecture, an office that has taken a truly multidisciplinary approach to architecture and design since its inception in 1990. Over the past few years, NOX has realized a wide variety of projects, including *Soft City*, a television production for VPRO TV (1993), the magazines *NOX A, B, C,* and *D* (1992–1995), *SoftSite*, a "liquid" city generated by behavior on the Internet and projected on the facade of the Netherlands Architecture Institute done for the V_2 Organization in Rotterdam (1996), and *H2O eXPO*, a water pavilion commissioned by the Dutch Ministry of Transport, Public Work and Water Management (1997) that integrated the design principles of architecture and interactive installation. NOX's work has been featured in exhibitions such as *Heavenly Bodies* at Galerie Peeters in Eindhoven, The Netherlands (1994) and *Transarchitectures 02* at the Institute Français d'Architecture in Paris (1997), which traveled to New York, Graz, Austria, and Los Angeles. Spuybroek lectures extensively in the Netherlands and abroad, and has taught at numerous universities and academies since 1991. He is also the editor of *FORUM*, a bilingual architectural quarterly published since 1995. NOX was awarded the Zeeland Architecture Prize in 1998.

Gabriel Orozco

Gabriel Orozco was born in Veracruz, Mexico, in 1962. He currently lives and works in New York and Mexico City. His first major solo exhibition was held at the Kanaal Art Foundation in Kortrijk, Belgium in 1993. He has been the subject of a number of one-person exhibitions, including *Projects 41* at The Museum of Modern Art in New York (1993), the Musée d'Art Moderne de la Ville de Paris (catalogues) (1995 and 1998), the Institute of Contemporary Arts in London (catalogue), Kunsthalle Zürich (catalogue), the Art Gallery of Ontario in Toronto, Marian Goodman Gallery in New York (all in 1996), the Stedelijk Museum in Amsterdam, and the Musées de Marseille, Chapelle, Centre de la Vieille Charité in France (both in 1997). His work has also appeared in a number of international group exhibitions, including *Aperto '93* at the *XLV Venice Biennale* (catalogue) (1993), *Cocido y Crudo* at the Museum Nacional Centro de Arte Reina Sofía in Madrid (catalogue) (1994), *1995 Biennial Exhibition* at the

Whitney Museum of American Art in New York (catalogue) (1995), the *95 Kwangju Biennial: Beyond the Borders* in South Korea (catalogue) (1995), *Documenta X* in Kassel, Germany (catalogue), *Skulptur Projekte in Münster,* Germany (catalogue), and the *1997 Whitney Biennial* at the Whitney Museum of American Art in New York (catalogue) (all in 1997).

Pan Sonic (Mika Vainio and Ilpo Väisänen)

Mika Vainio was born in Helsinki, Finland, in 1963. Ilpo Väisänen was born in Kuopio, Finland, in 1963. Pan Sonic was formed in 1994. As recording artists they have performed more than 100 live shows in Europe, North America, and Asia. Vainio currently lives in Barcelona, Spain, and Väisänen lives in Turku, Finland. Vainio has appeared in a number of international exhibitions, including a solo exhibition at the Musée d'Art Moderne de la Ville de Paris (1997) and group exhibitions such as *Manifesta 1* in Rotterdam, The Netherlands (catalogue) (1996) and *Nuit Blanche* at the Musée d'Art Moderne de la Ville de Paris (catalogue) (1998). Vainio and Väisänen appeared together as Pan Sonic in the exhibition *Rude Mechanics* at the Beaconsfield Gallery in London (1996), during which they conducted a six-week-long "live" performance. Pan Sonic has released a number of recordings on CD and vinyl, including *Muuntaja,* released by Sähkö Recordings, Finland (1994), *Vakio,* released by Blast First UK (1995), *Osasto,* released by Blast First UK (1996), *Kulma,* released by Blast First UK (1997), and *Endless,* their collaboration with Alan Vega released by Blast First UK (1998).

S.a.n.a.a. (Kazuyo Sejima, Ryue Nishizawa & Associates)

Kazuyo Sejima was born in Ibaraki Prefecture, Japan, in 1956. Ryue Nishizawa was born in Kanagawa Prefecture, Japan, in 1966. They both live and work in Tokyo. Sejima established the office Kazuyo Sejima & Associates in 1987 and soon after was awarded several prizes for her work in the field of architectural and industrial design, including Third Prize in the Yokohama International Port Terminal Design Competition in 1995. A number of Sejima's architectural projects have been realized in Japan over the past few years, including her *Seiyaku Women's Dormitory* (1991), *Pachinko Parlor 1 and II* (1993), *Y-House* (1994), and *Pachinko Parlor III* (1996). Her first solo exhibition took place at the National Panasonic Gallery in Tokyo (1989). Her work has also been seen in a number of other exhibitions, including *Kazuyo Sejima 12 Projects* at MA Gallery in Tokyo (1993) and *Japanese Contemporary Design* at the National Museum of Modern Art in Seoul, South Korea (1994). Sejima began her collaboration with Ryue Nishizawa in 1995. In 1997 they established S.A.N.A.A. Ltd., an architectural firm based in Tokyo. Since the founding of S.A.N.A.A., they have completed a number of works, including the *Gifu Kitagata Apartment* (1998). They are currently working on an extension to the Museum of Contemporary Art in Sydney, Australia. In 1998 they were awarded the Architecture Institute of Japan Award for *Multimedia Workshop.*

Thomas Schütte

Thomas Schütte was born in Oldenburg, West Germany, in 1954. He currently lives and works in Dusseldorf, Germany. His first solo exhibition was held at Galerie Arno Kohnen in Dusseldorf in 1979. Most recently he has been the subject of a number of one-person exhibitions at the Whitechapel Art Gallery in London, Gallery Konrad Fischer in Germany, and Marian Goodman Gallery in New York (all in 1997), the De Pont Foundation in Tilburg, The Netherlands, the Fundação de Serralves in Porto, Portugal, and the Dia Center for the Arts in New York (all in 1998). His work has appeared in a number of important international group exhibitions, including *The European Iceberg* at the Art Gallery of Ontario in Toronto (catalogue) (1985), *Skulptur Projekte in Münster,* Germany (catalogues) (1987 and 1997), *Documenta VIII* (1987), *Documenta IX* (1992), and *Documenta X* (1997) in Kassel, Germany (catalogues), and *Distemper: Dissonant Themes in the Art of the 1990s* at the Hirshhorn Museum and Sculpture Garden in Washington, D.C. (catalogue) (1996).

Roman Signer

Roman Signer was born in Apenzell, Switzerland, in 1938. He currently lives and works in St. Gall, Switzerland. His first solo exhibition was at Galerie Wilma Lock in St. Gall (catalogue) in 1973. Most recently he has appeared in a number of one-person exhibitions at the Moore College of Art and Design in Philadelphia (catalogue) and the Swiss Institute in New York (both in 1997), and Galerie Barbara Weiss in Berlin (1998). His work has also appeared in a number of international group exhibitions, including the *XXXVII Venice Biennale* (catalogue) (1976), *Heart of Darkness* at the Rijksmuseum Kröller-Müller in Otterlo, The Netherlands (1994), *Self-Construction* at the Museum Moderner Kunst Stiftung Ludwig, 20er Haus in Vienna (1995), *Model Home* at the Clocktower Gallery in New York (1996), *Alpenblick* at the Kunsthalle Vienna and Kunsthaus Aarau in Austria, and *Skulptur Projekte in Münster,* Germany (catalogue) (1997).

Alexandr Sokurov

Alexandr Sokurov was born in Irkutsk, U.S.S.R., in 1951. He currently lives and works in St. Petersburg, Russia. In 1968 he began his studies in history at the University of Gorky. He then went to the VGIK in Moscow to study film directing. Upon completion of his degree at the film academy he went to Leningrad to work for Lenfilm and the Documentary Studio of Leningrad. From 1970 to 1987 he

made two full-length and several short features as well as six documentary films, each of which was banned by the Soviet film censors. After the political situation changed in 1987 and due to the efforts of the Filmmakers Union, almost all of his films have now been released. His films have been screened across the globe in a wide variety of film festivals, such as the Berlin International Film Festival, the New York Film Festival, the Toronto International Film Festival, and the Rotterdam International Film Festival, and he has been featured in exhibitions such as *Documenta X* in Kassel, Germany (catalogue) (1997). His first film, *Maria (Krestjanskaja elegija)/Maria (Peasant Elegy)* was completed in 1975. Most recently he has released *Kamen/ The Stone/De steen* (1992), *Elegia iz Rossii (Etyudy dla na)/Elegy from Russia (Sketches for Sleep)* and *Tichie stranicy/Whispering Pages* (both 1993), *Dukhovnye golosa/Spiritual Voices* (1995), *Vostochnaya elegya* (1996), and *Mat' i syn/Mother and Son* (1997). *Spiritual Voices* recently appeared in an exhibition at Frith Street Gallery in London (1998).

YUTAKA SONE

Yutaka Sone was born in Shizuoka, Japan, in 1965. He currently lives and works in Tokyo. His first solo exhibition was held at the Contemporary Art Center, Art Tower Mito in Mito, Japan (1993). More recently he has had a number of one-person exhibitions at Bunkamura Gallery in Tokyo (1996), Hiroshima Contemporary Art Museum in Hiroshima, Gallery Side 2 in Tokyo (1997), Shiseido Art House in Kakegawa, Japan, and Navin Taxi Gallery in Bangkok, Thailand (both in 1998). His work has appeared in a number of international group exhibitions, including *Nutopi* at the Rooseum Center for Contemporary Art in Malmö, Sweden (catalogue) (1995), *Skulptur Projekte in Münster*, Germany (catalogue), and *Cities on the Move* at the Wiener Secession in Vienna (catalogue) (both in 1997). He was awarded an artist residency at Art Pace in San Antonio in 1998.

THOMAS STRUTH

Thomas Struth was born in Geldern, West Germany, in 1954. He currently lives and works in Dusseldorf, Germany. His first solo exhibition was at P.S. 1 Contemporary Art Center in New York in 1978. He has been the subject of one-person exhibitions at the Kunsthalle Bern, Switzerland (catalogue) (1987), The Renaissance Society in Chicago (catalogue) (1990), the Hirshhorn Museum and Sculpture Garden in Washington, D.C. (1992), the Institute of Contemporary Art in Boston, and the Institute of Contemporary Arts in London (catalogue) (both in 1994), Galerie Max Hetzler in Berlin (1996), Marian Goodman Gallery in New York (1997), and Marian Goodman Gallery in Paris (1998). His work has also appeared in a number of international

group exhibitions, including *Skulptur Projekte in Münster*, Germany (catalogue) (1987), *Aperto '90* at the *XLIV Venice Biennale* (1990), the *Carnegie International* at the Carnegie Museum of Art in Pittsburgh (catalogue) (1991), *Documenta IX* in Kassel, Germany (catalogue) and *Photography in Contemporary German Art: 1960 to the Present* at the Walker Art Center in Minneapolis, Minnesota (catalogue) (both in 1992), *The Epic in the Everyday* at the Hayward Gallery in London (1994), and *Evidence: Photography and Site* at the Wexner Center for the Arts, The Ohio State University in Columbus, Ohio (catalogue) (1997).

Doug Aitken
Diamond Sea 1997
video projection, laserdisc
running time: 20 minutes
Collection Walker Art Center, Minneapolis
Justin Smith Purchase Fund, 1997

James Angus
Neuschwansteins 1998
wood
26 x 16 x 41 in.
Courtesy the artist and Gavin Brown's enterprise,
New York

Alighiero Boetti
Mappa 1992–1993
hand embroidery on cotton
100 x 228 in.
Collection Giordano Boetti, Rome

Andrea Bowers
A Sense of Clear Self-evidence 1997
slides, slide projectors, mirrors
variable dimensions
Courtesy the artist, Los Angeles

Maurizio Cattelan
Novecento (Twentieth Century) 1997
taxidermic horse
79 x 106½ x 27½ in.
Collection Castello di Rivoli–Museo d'Arte
Contemporanea, Rivoli (TO), Italy

Thomas Hirschhorn
Spin-off 1998
mixed-media installation
variable dimensions
Courtesy the artist and Niklas Svennung Gallery,
New York

Mats Hjelm
White Flight 1997
video projection, 2 laserdiscs
running time: continuous 40-minute loops
variable dimensions
Courtesy the artist and Galleri Index, Stockholm

Huang Yong Ping
The Pharmacy 1995–1997
mixed-media installation
234 x 109½ in.
Courtesy the artist and Jack Tilton Gallery, New York

Wing Young Huie
High School Graduation Party, Lake Street, 1997 1997
black-and-white photomural
Courtesy the artist, Minneapolis

Wing Young Huie
National Night Out, Powderhorn Park, 1997 1997
black-and-white photomural
Courtesy the artist, Minneapolis

Wing Young Huie
Members of the Cambodian Bloods, 1998 1998
black-and-white photomural
Courtesy the artist, Minneapolis

William Kentridge
Ubu Tells the Truth 1997
video projection, laserdisc
running time: 7 minutes
Courtesy the artist, Johannesburg

Bodys Isek Kingelez
Ville Fantôme 1996
paper, plastic, cardboard
47¼ x 224⅜ x 94½ in.
C.A.A.C.–The Pigozzi Collection, Geneva

Koo Jeong-a
hùmpty-dùmpty 1998
mixed-media installation
variable dimensions
Courtesy the artist, Paris

Shirin Neshat
Turbulent 1998
video projection, 2 laserdiscs
Edition of 3, plus 1 AP
running time: 10 minutes
Collection Camille Hoffmann, Naperville, Illinois

Director of Photography: Ghasem Ebrahimian
Female Performer: Sussan Deyhim
Male Performer: Shoja Azari
Male Vocal: Shahram Nazeri
Music Composition: Kambiz Roshan Ravan and
Sussan Deyhim
Poetry: Rumi
Producer: Bahman Soltani

Cady Noland
Oozewald 1989
black silkscreen on metal, flag
AP; edition of 4, plus 1 AP
71 ⅜ x 33 ½ x ⅜ in.
Courtesy the artist, New York, with original photograph
courtesy Bob Jackson

Cady Noland
SLA Group Shot #1 1991
black silkscreen on aluminum
AP; edition of 1, plus 1 AP
78 ½ x 57 x ⅜ in.
Courtesy the artist, New York

NOX (Lars Spuybroek)
NearDeathHotel 1998
color photomural
Courtesy NOX, Rotterdam

Gabriel Orozco
Isla en la Isla (Island within an Island) 1993
cibachrome print
16 x 20 in.
Collection Walker Art Center, Minneapolis
T. B. Walker Acquisition Fund, 1996

Gabriel Orozco
Kitchen Door Maze 1997
fiberboard, wood, wired glass, hinges, paint,
11 drawings
116 x 248 x 291 in. overall installed
Courtesy the artist and Anthony D'Offay Gallery,
London

Pan Sonic (Mika Vainio and Ilpo Väisänen)
Linua 1998
sound installation with oscilloscope, CD, video projector
variable dimensions
Courtesy the artists, Barcelona, Spain

**S.A.N.A.A. (Kazuyo Sejima and Ryue Nishizawa
& Associates)**
Model for *The Richard H. Driehaus International Design
Competition for IIT Campus Center* 1998
acrylic, polycarbonate
1 ½ x 65 ¾ x 32 ½ in.
Courtesy S.A.N.A.A. Ltd., Tokyo

Thomas Schütte
Die glorreichen Sieben 1992–1993
ceramic heads on steel pedestals
heads: 7 ½ x 5 ½ x 6 ⅛ in.
pedestals: 55 ½ x 12 in.
Collection Rachel and Jean-Pierre Lehmann, New York

Roman Signer
Bett 1996
single-channel videotape transferred to laserdisc
running time: 3 minutes
Collection Walker Art Center, Minneapolis
Art Center Acquisition Fund, 1998

Alexandr Sokurov
Spiritual Voices (Dukhovnye golosa) 1995
single-channel videotape
running time: 5 ½ hours
Courtesy the artist and zero film Gmbh, Berlin

Yutaka Sone
Amusement 1998
marble
18 ⅞ x 23 ⅝ x 74 ¹³⁄₁₆ in.
Courtesy the artist and David Zwirner Gallery,
New York

Thomas Struth
Musée du Louvre 4, Paris 1989
C-print
Edition 4 of 10
72 ½ x 85 ½ in. framed
Marieluise Hessel Collection on permanent loan to the
Center for Curatorial Studies, Bard College, Annandale-
on-Hudson, New York

REPRODUCTION CREDITS

The publisher wishes to thank the artists for permission to reproduce their work in this catalogue: unless otherwise noted, all images are courtesy and copyright the artists. In addition, the publisher wishes to acknowledge the following for images reproduced in this book: Axon Video Company ©1988 (page 23); Blast First UK, London, photo by Perou (page 71); Gavin Brown's enterprise, New York (pages 35–36, photo by Pellion, 79, 80); British Film Institute Stills, Posters and Designs, London (cover and pages 2–3, 19); Anthony D'Offay Gallery, London (pages 43–45); Barbara Gladstone Gallery, New York (page 77); Marian Goodman Gallery, New York (page 46); Galleri Index, Stockholm (pages 57–58); Israel Museum, Jerusalem (page 11); New Yorker Video ©1977 (page 22); Cady Noland with original photograph courtesy Bob Jackson (page 60); Jerry Ohlinger's Movie Material Store, New York (pages 14, 21, 25); Photofest, New York (page 20); Niklas Svennung Gallery, New York (pages 87–88); 303 Gallery, New York (page 47–50); Jack Tilton Gallery, New York (pages 73–76); Walker Art Center, Minneapolis, photos by Dan Dennehy (pages 39–42, 78); Rachel and Jean-Pierre Lehmann, photos by Lina Bertucci (pages 81–84); Galerie Barbara Weiss, Berlin (page 89); zero film Gmbh, Berlin (pages 37–38); and David Zwirner Gallery, New York, photo by Yutaka Sone (page 72).

Unfinished History is made possible by major support from The Rockefeller Foundation. Additional support is provided by the Mondriaan Foundation, the International Artists' Studio Program in Sweden (IASPIS) in Stockholm, and the Finnish Fund for Art Exchange (FRAME) in Helsinki. This exhibition catalogue is made possible in part by support from the Elizabeth Firestone Graham Foundation. Walker Art Center publications are made possible in part by a grant from the Andrew W. Mellon Foundation.

Major support for Walker Art Center programs is provided by the Minnesota State Arts Board through an appropriation by the Minnesota State Legislature, the Lila Wallace-Reader's Digest Fund, the National Endowment for the Arts, Dayton's, Mervyn's, and Target Stores by the Dayton Hudson Foundation, The McKnight Foundation, the General Mills Foundation, Coldwell Banker Burnet, the Institute of Museum and Library Services, the American Express Minnesota Philanthropic Program, the Honeywell Foundation, The Cargill Foundation, The Regis Foundation, The St. Paul Companies, Inc., U.S. Bank, the 3M Foundation, and the members of the Walker Art Center.

Northwest Airlines, Inc. is the official airline of the Walker Art Center.